MIDDLESBROUGH

WITHDRAWN

LIBRARIES AND INFORMATION

009097458 1

Middlesbrough Libraries

D0586444

# CONFESSIONS OF THE
# WORLD'S BEST FATHER

DAVE ENGLEDOW

# CONFESSIONS OF THE
# WORLD'S BEST FATHER

## DAVE ENGLEDOW

MICHAEL JOSEPH
AN IMPRINT OF
PENGUIN BOOKS

## MICHAEL JOSEPH

Published by the Penguin Group
Penguin Books Ltd, 80 Strand, London WC2R 0RL, England
Penguin Group (USA) Inc., 375 Hudson Street, New York, New York 10014, USA
Penguin Group (Canada), 90 Eglinton Avenue East, Suite 700, Toronto, Ontario, Canada M4P 2YR
(a division of Pearson Penguin Canada Inc.)
Penguin Ireland, 25 St Stephen's Green, Dublin 2, Ireland (a division of Penguin Books Ltd)
Penguin Group (Australia), 707 Collins Street, Melbourne, Victoria 3008, Australia
(a division of Pearson Australia Group Pty Ltd)
Penguin Books India Pvt Ltd, 11 Community Centre,
Panchsheel Park, New Delhi – 110 017, India
Penguin Group (NZ), 67 Apollo Drive, Rosedale, Auckland 0632, New Zealand
(a division of Pearson New Zealand Ltd)
Penguin Books (South Africa) (Pty) Ltd, Block D, Rosebank Office Park, 181 Jan Smuts Avenue,
Parktown North, Gauteng 2193, South Africa

Penguin Books Ltd, Registered Offices: 80 Strand, London WC2R 0RL, England

www.penguin.com

First published by Gotham Books, an imprint of Penguin Group (USA) LLC 2014
First published in Great Britain by Michael Joseph 2014
001

Copyright © Dave Engledow, 2014

The moral right of the author has been asserted

All rights reserved
Without limiting the rights under copyright
reserved above, no part of this publication may be
reproduced, stored in or introduced into a retrieval system,
or transmitted, in any form or by any means (electronic, mechanical,
photocopying, recording or otherwise), without the prior
written permission of both the copyright owner and
the above publisher of this book

Set in Populaire and Univers
Designed by Alison O'Toole
Colour reproduction by Altaimage, London
Printed and bound in Italy by Printer Trento Srl

A CIP catalogue record for this book is available from the British Library

ISBN: 978-0-718-17916-8

MIX
Paper from
responsible sources
FSC
www.fsc.org  FSC® C018179

Penguin Books is committed to a sustainable
future for our business, our readers and
our planet. This book is made from Forest
Stewardship Council™ certified paper.

FOR JEN AND ALICE BEE

# DAY 1

Today we brought our beautiful baby girl home from the hospital. Alice Bee. I still can't believe how amazing she is — so perfectly sweet and tiny.

She really doesn't do much yet — mainly spending her time sweetly and quietly sleeping, and only occasionally waking up to spend time underneath Jen's shirt. So far, new parenthood is a breeze, and I'm ready to live up to the moniker on that new coffee mug Jen gave me this morning.

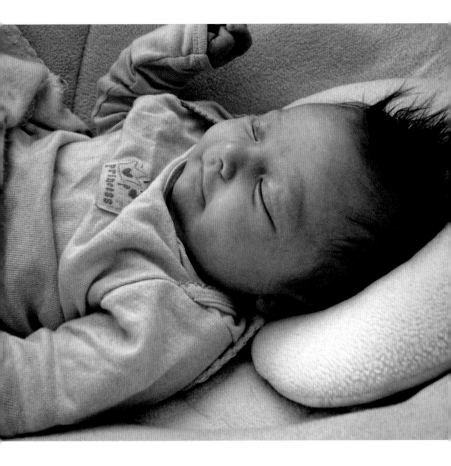

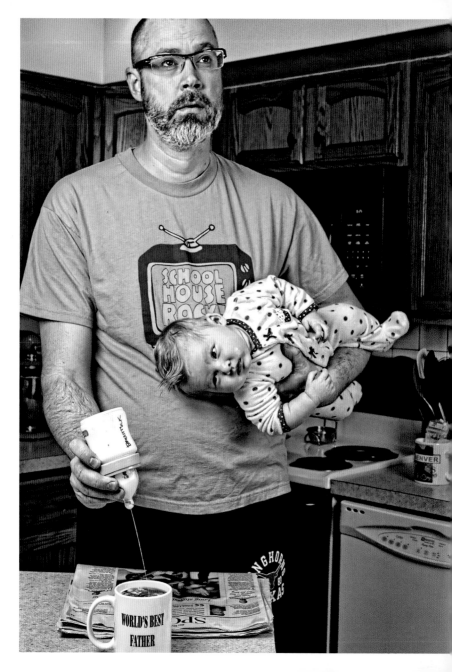

DAY 66

Apparently, fathering is not going to be quite as easy or glamorous as it looks on TV. These past nine weeks since Alice Bee arrived in our house have provided a nonstop barrage of crying, peeing, and pooping at all hours of the day and night, wreaking total havoc on my daily routine.

Alice Bee's constant need for attention has also prevented a proper replenishing of the groceries, meaning we were totally out of coffee creamer this morning. Luckily for me, when I checked the back of the fridge I discovered a cache of milk that Jen had bottled up for Alice Bee. I'll have to ask her where she bought this stuff — it was a bit sweeter and thicker than our regular milk, but my coffee was amazing.

**DAY 199**

It's been several months since my last entry, and I'm happy to report that things have greatly improved in our household. I'm back into my daily sports page and coffee routine, and those special bottles of milk Jen leaves for Alice Bee have totally replaced the creamer I normally use.

But the really great news is that Alice Bee now seems much more able to look after herself while Jen is out of the house. To honor this newfound independence, I agreed to let Alice Bee purchase a small stockpile of age-appropriate fireworks (we agreed to save the bottle rockets and M-80s until her third birthday).

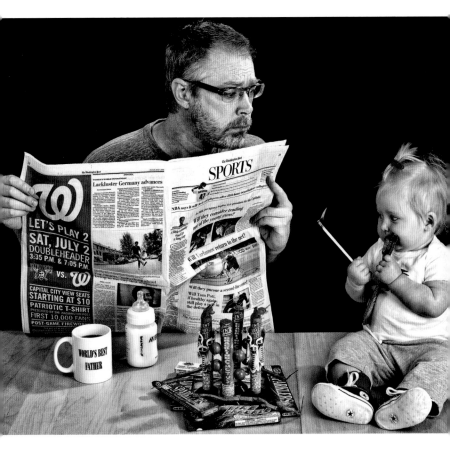

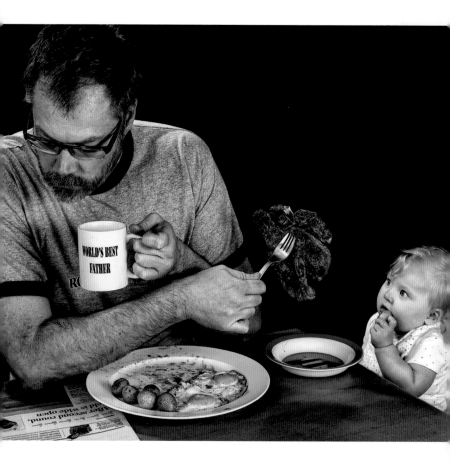

DAY 211

Jen is away for a week on an out-of-town assignment for her Army job. She claims to have told me about this on several occasions, but she also has a habit of sneaking these things past me while I'm reading the sports page, which leads me to occasionally/always forget what she tells me.

Not only did Jen leave me alone with Alice Bee for an entire week, she also neglected to leave clear instructions on how or what one is supposed to feed a baby. And to make matters worse, my stress level skyrocketed so high that I was forced to dramatically increase my coffee intake, meaning we used up all of Alice Bee's special milk bottles by the end of the first day.

I seem to recall Jen saying something a few weeks back about Alice Bee getting started on "solid foods," and nothing provides a more solid start to the day than a hearty breakfast of steak and eggs. Alice Bee wound up just eating the potatoes, because apparently the World's Best Mom hasn't yet taught her how to use a knife and fork.

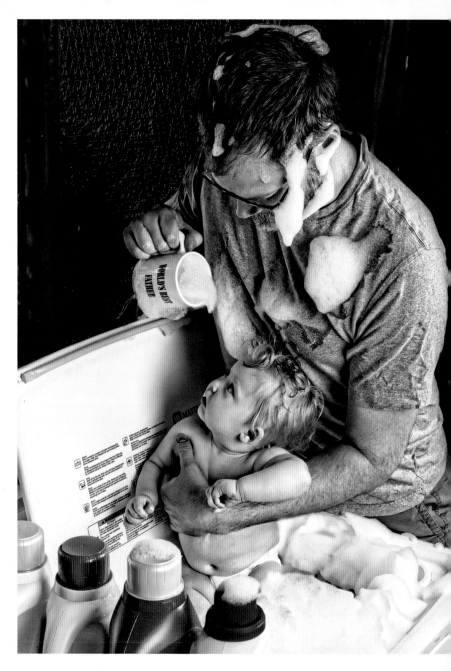

DAY 217

We have now been on our own for six days, and this morning I noticed that Alice Bee was quite a bit grungier than Jen normally keeps her.

Earlier in the week, I perfected a technique I was sure would revolutionize changing nappies — by simply adding a new nappy on top of the old one each morning, I had managed to keep my hands poop-free for days. However, I was now beginning to suspect that I had merely been prolonging the inevitable.

Since Jen also neglected to leave instructions for me on exactly how to bathe a baby, I had to figure it out on my own. I vaguely recalled reading somewhere that babies are unsafe in as little as two inches of water, which obviously ruled out using the bathtub. Luckily, I remembered that our washing machine has something called a "delicate cycle," which seemed entirely appropriate for someone with such smooth skin. Stripping Alice Bee down to the original nappy, I managed to get her sparkling clean just in time for Jen's return.

DAY 240

Jen has been reading a bunch of baby-development books about benchmarks and milestones for newborns. She assures me that Alice Bee is doing really great in almost every category, but I'm still a little concerned that these books don't cover all of the skills I think Alice Bee will need in order to be as successful as her old man.

I'm sure Jen won't mind that I raided the joint savings account to pay for some new developmental / educational toys — nothing but the best for our little girl.

Today has truly been a great day. Alice Bee and I spent the whole afternoon together, working on essentials like improving her twitch reflexes, how to avoid the cops during a six-star police chase, and the proper way to mod a shotgun for zombie killing.

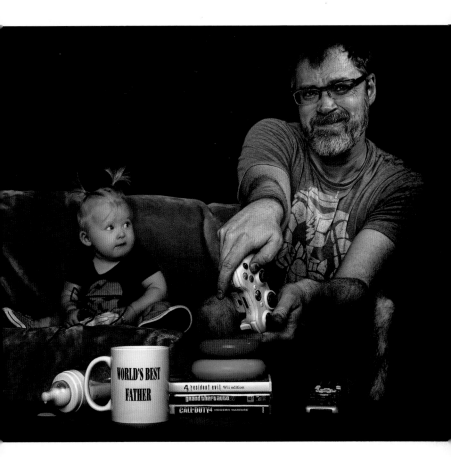

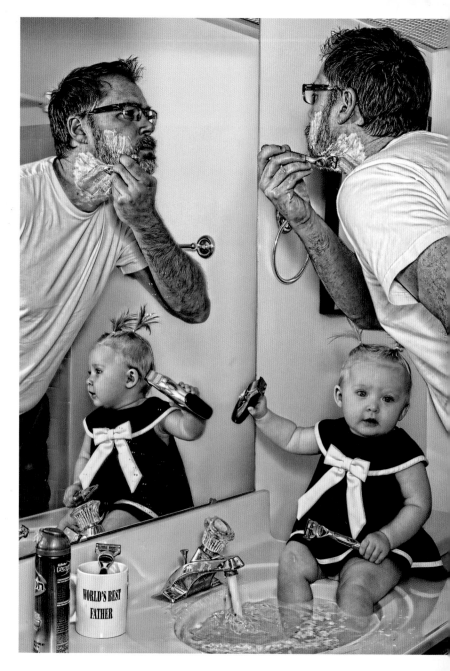

DAY 246

I normally hate shaving. In the past ten years, I think I've been clean-shaven exactly twice — once for Jen on our wedding day and the other time for the job interview with my current employer (two people who are probably both now wondering what happened to that fresh-faced guy they first met so many years ago).

Despite my contempt for the whole process, I definitely did not want to rob Alice Bee of that iconic father–daughter bonding moment associated with learning to shave, and now that she is old enough to assist, maybe shaving won't be quite as horrendous as usual. She *loves* playing in the foamy water, and is turning out to be quite good at handing me the proper tools when I require them. Plus, having her around while I shave makes me feel like I'm in one of those Norman Rockwell paintings.

DAY 248

This morning the TV alerted us to the fact that a big weather system is headed our way. I've always loved stormy days, and I'm really excited about sharing this new experience with Alice Bee.

I spent the morning going over all the details of how to prepare our home for the impending storm and divvying up assignments. I sent Jen to the store to buy staples (batteries, mayonnaise, bottled water and toilet paper) while Alice Bee and I stayed behind to take care of tasks around the house.

I easily completed my duties getting the inside of the house ready, and now that the rain is beginning to fall, I have a wonderful surprise ready for Alice Bee: a warm cup of hot cocoa, her favorite stuffed toy, and a cozy blanket are here waiting for her. I sure hope she shows up soon!

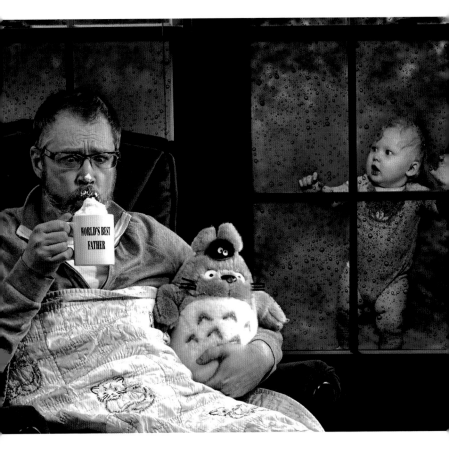

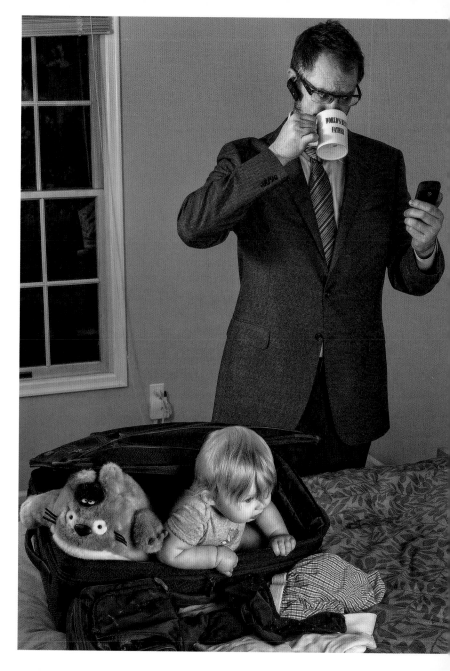

**DAY 251**

I'm on my first out-of-town business trip since Alice Bee was born, and today has been one of the most grueling days of travel I've ever experienced.

For starters, I am obviously very much out of shape — I could barely even lift my carry-on bag into the overhead bin on the plane. I must have overpacked it, because it took me forever to get the bin door shut. I think I must also be suffering from some sort of Alice Bee–induced separation anxiety, because the entire time I was trying to sleep on the plane, I kept thinking I could hear her crying.

I finally arrived and started settling into my room for the night when I got a frantic text message from Jen saying that she hadn't seen Alice Bee all day. I'm gone for less than twenty-four hours and things are already falling apart without me.

DAY 258

I love s'mores. Even before becoming a father myself, I used to daydream about the pure joy of introducing my progeny to the gooey, chocolaty, graham-crackery decadence of a perfectly crafted s'more. But Jen insists that Alice Bee is still too young to go camping.

Today, however, I had an epiphany – I could teach Alice Bee how to make s'mores from the safety of our own backyard using charcoal briquettes instead of building a dangerous campfire.

I was so proud – she quickly figured out how to spear the marshmallows with the pointed stick I carved for her. However, the charcoal fire she built was not anywhere near big enough to get a proper char on her marshmallows, providing me the perfect opportunity to educate her about the magical properties of lighter fluid.

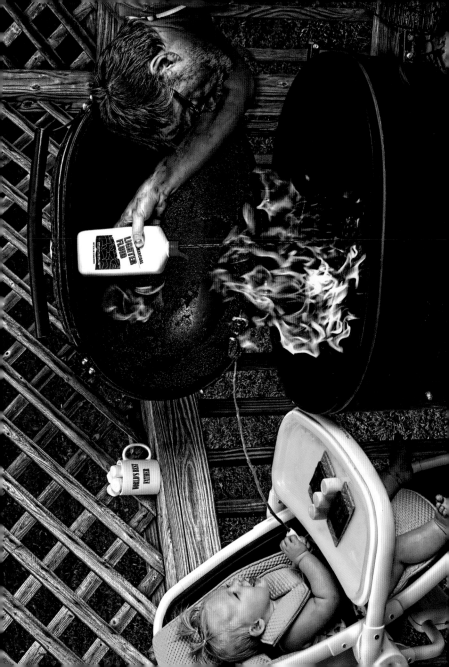

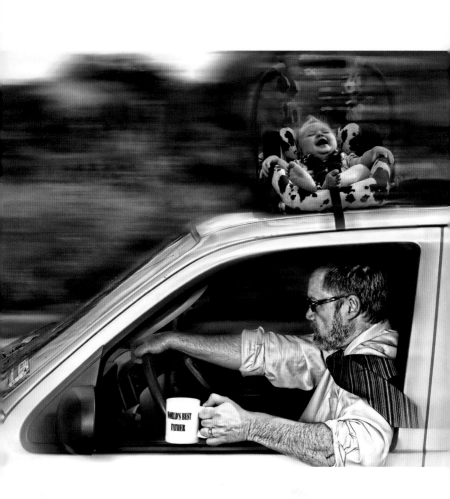

**DAY 267**

Today started out like any other morning – I woke up at my normal time, brewed some coffee, read the sports page and was headed out the door a full two minutes ahead of schedule when I suddenly heard crying coming from upstairs. Only then did I remember that today was my day to take Alice Bee to pre-school.

I frantically got her dressed, strapped her into the car seat, and rushed outside to the car. Luckily as I was opening the car door, my keen sense of observation kicked in, alerting me that we had forgotten to put her shoes on. I raced back into the house, grabbed the shoes, jumped into the car, and put the pedal to the metal. While driving, I had the strangest sense that I had forgotten something else, but it must not have been that important because I didn't hear a peep out of Alice Bee for the entire trip.

DAY 274

After a hard day on the job, nothing could be better than walking through the front door, yelling out "Honey, I'm home!" and immediately receiving an expertly poured martin – minuscule crystals of ice suspended in the perfectly blended gin and vermouth, frost forming on the chilled glass, and two deliciously salty olives to provide sustenance before dinner.

. . . and this is exactly why Jen requires me and Alice Bee to have one ready and waiting when she gets home from work.

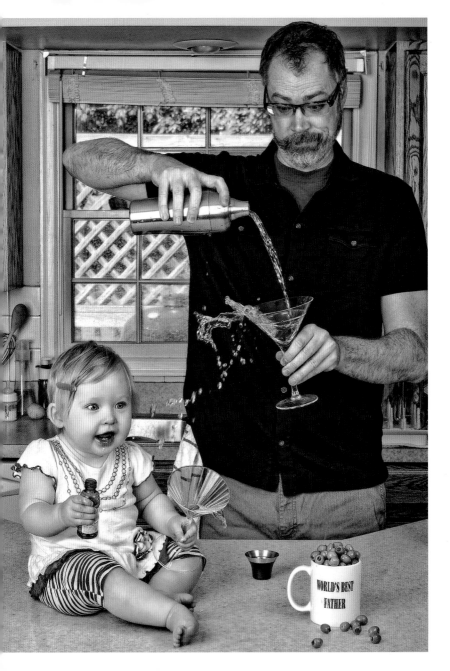

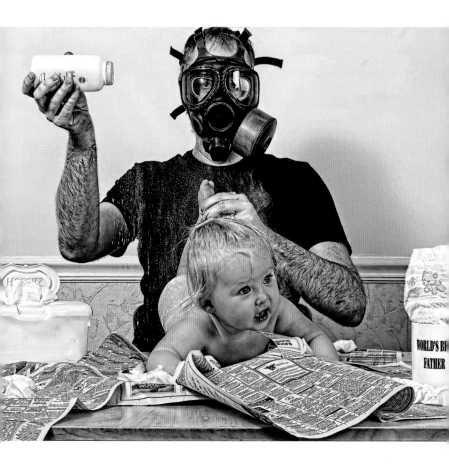

DAY 281

One of the unanticipated advantages of marrying a US Army chemical officer is the never-ending supply of cool gadgets and gear lying around our house. Of course, as a civilian, I am never under any circumstances allowed to touch or play with Jen's things, but sometimes I just can't help myself . . . especially when some of these tools are just so perfectly suited for fathering.

**DAY 302**

Oh, man. This morning, Jen finally figured out what has been happening to those special bottles of milk she leaves in the fridge for Alice Bee. Over the past six months, I've tried so hard to switch back to regular creamer, but I just can't seem to do it.

This morning, things came to a head when Jen discovered there was no milk at all for Alice Bee in the fridge. I immediately offered to go to the store to buy some more (hoping she'd finally reveal the source) but no luck. She muttered something like "You really have no idea how much time and effort I put into giving Alice Bee the best nutrition, do you?!" and stormed off. Seriously, how hard could it be to put milk in a baby bottle?

But then, tonight, I rediscovered why my wife is the best person I know. When I opened the fridge to get Alice Bee one of her special bottles, I discovered that Jen had thoughtfully stocked the shelf with some new special bottles just for me.

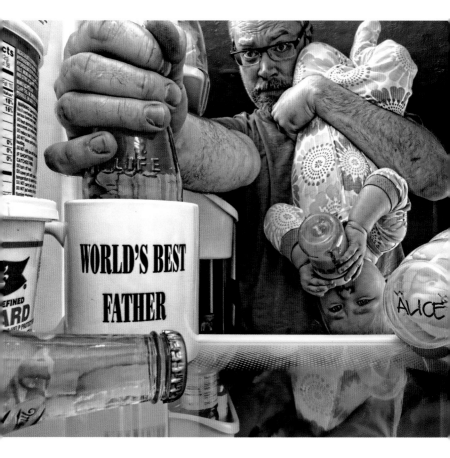

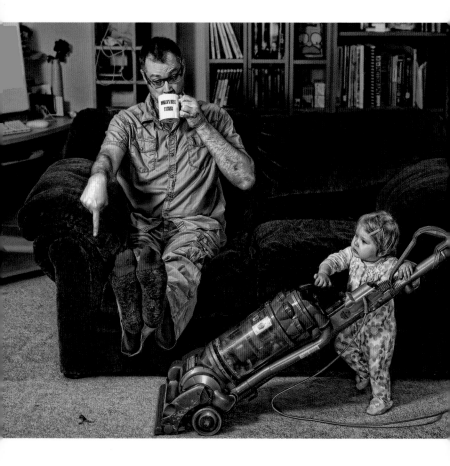

**DAY 309**

My only previous parenting experience comes from seven-plus years as a dog owner. Since about 99 percent of the techniques we used with Big Earl seem to also work perfectly on Alice Bee, I am always fascinated by the rare example of how a human child is actually different from a puppy.

Case in point — I'm pretty sure all dogs are afraid of vacuum cleaners. Earl would cower under the covers on the bed anytime we even approached the closet where we stored the vacuum. I thought it was a pretty logical assumption that Alice Bee would also have this same natural aversion.

Today, however, I was pleasantly surprised to discover that I had been underestimating Alice Bee this entire time. After Jen told me to clean up my mess in the basement, I decided to see if Alice Bee wanted to help, and quickly discovered that she wasn't the least bit afraid of the noise. The floor got cleaned and I learned that at eleven months of age my daughter is already more highly evolved than a retired greyhound.

DAY 317

Halloween! According to Jen, Alice Bee is not yet old enough to go trick-or-treating with me; however her small size provided an invaluable advantage in helping to prepare our family's jack-o'-lantern this year.

The part I've always hated most about carving a jack-o'-lantern is cleaning out all of those slimy, stringy pumpkin guts. Fortunately, Alice Bee fits in there perfectly and had no problems getting the inside of that pumpkin as smooth as . . . well, as her own bottom.

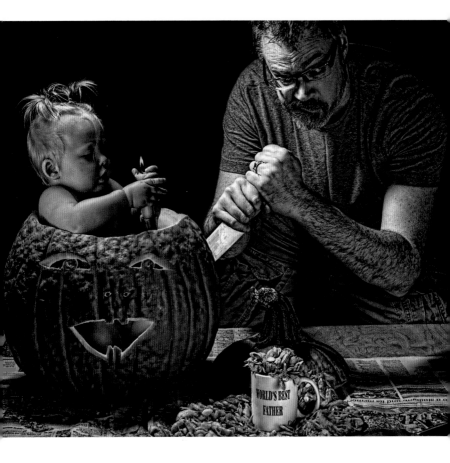

**DAY 341**

Thanksgiving is such an important time of year to reflect on all the things for which we are thankful, and I really want to make Alice Bee's first one in our family special. I'm pretty sure we're going to meet that goal today!

I spent the entire morning introducing Alice Bee to the billowy joys of home-smoking a turkey, but the bigger surprise is that I'm finally going to allow her to realize another dream. Ever since our pumpkin carving in October, she's been obsessed with learning to use a knife, but her mother keeps telling us that she's too young. Well, unbeknownst to Jen (who is currently outside apologizing to the neighbors for all the smoke), I ordered Alice Bee her very own electric knife (the electricity makes it safer than a plain old chef's knife) and she is going to have the honor of carving her very first bird today.

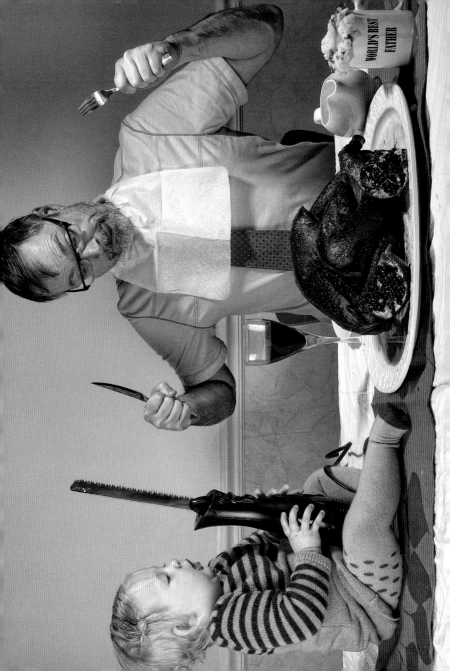

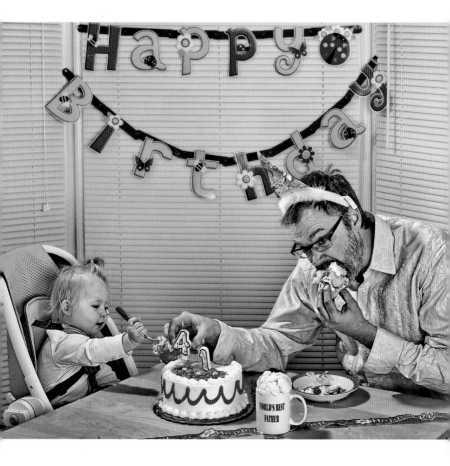

**DAY 365**

I was born on December 13, which means I have spent the past forty years having my special day overlooked and overshadowed by the bigger holiday that falls twelve days later. And then, to make matters worse, Jen went and delivered Alice Bee on December 18, meaning that my special day will now be overshadowed by not one but two more important celebrations.

However, today I did figure out a trick that should make things a bit more tolerable for the next nine years. Since I'm exactly forty years older than Alice Bee, I can easily modify her birthday cake to claim it as my own.

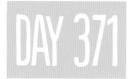
**DAY 371**

Very few things scare Alice Bee, but apparently the mall Santa is one of them. It's Christmas Eve, and Jen tried to take Alice Bee to pose for pictures with Santa. For some reason, the second that Alice Bee landed on that hairy, red-suited fat man's lap, she began screaming and crying uncontrollably and wouldn't even cooperate long enough for Jen to get a proper photograph to send to the grandparents.

After we got home and Alice Bee settled down, I poured myself a little bit of Christmas cheer. Perhaps I had one too many mugsful because I readily agreed to let Alice Bee gather up some firewood and light a roaring yuletide fire, never once suspecting that she might have had an ulterior motive.

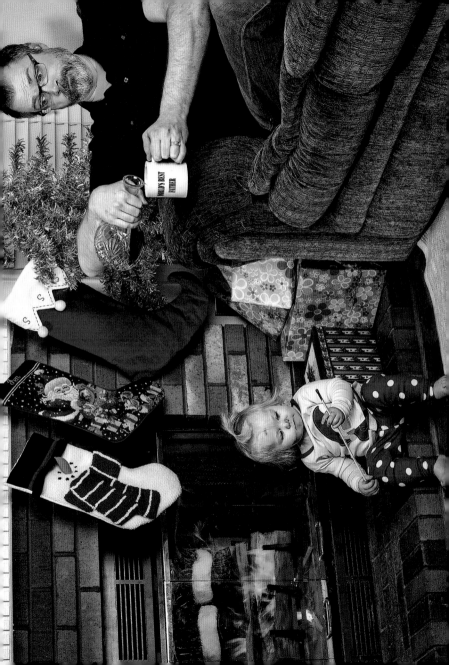

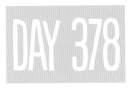

**DAY 378**

I hate New Year's Eve. I hate knowing that another year has passed. I hate staying up until midnight with the sole purpose of watching other people on TV having more fun than I am. I suppose I like the Champagne part, and kissing my wife at midnight. But I mostly hate it.

Alice Bee, on the other hand, is super-excited for New Year's Eve this year. She's under the impression that the Baby New Year will magically appear at midnight, and she can't wait to show Jen and me how she is so much bigger and wiser than him.

In anticipation of the big moment, Alice Bee gathered up all of her old milk bottles and was about to throw them away to really drive home the point that she's no longer a little baby. I had a much better idea, though, and she was really excited to put her bottles to a more grown-up use.

**DAY 386**

Alice Bee loves fruit. Fresh fruit, fruit cups, fruit snacks, Fruit by the Foot. Jen and I struggle to get her to eat anything else. "I wan' a f'uit 'nack!! I wan' mo' f'uit!!" is pretty much all we hear from her these days.

It's gotten so bad that she will often resort to bargaining with us when we tell her she's had enough, even stooping to subterfuge if she thinks it will result in more fruit for her. I'm usually pretty good at seeing through these amateurish attempts at trickery, but today she totally outsmarted me.

She started out by betting me a fruit cup that she could solve the tower puzzle faster than I could. This seemed like a sucker's bet — little did she know that I was the *master* of this toy when I was a kid.

Five seconds into the battle, I realized that not playing this game for forty years had put me at a distinct disadvantage. Not only did Alice Bee win, I even had to give her *two* fruit cups in order to ensure that she wouldn't reveal the results of our contest to Jen.

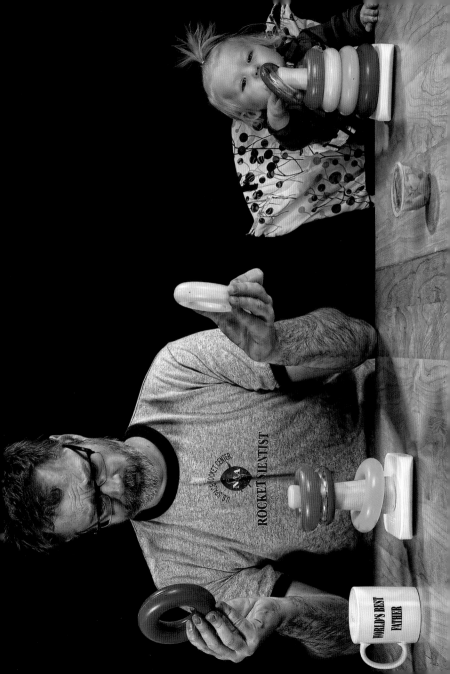

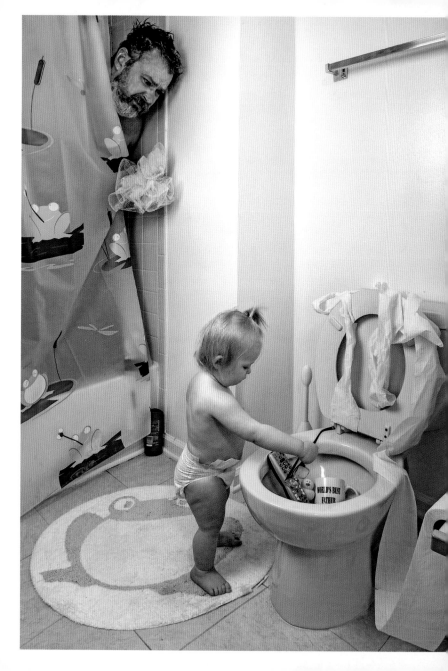

**DAY 393**

Alice Bee has become obsessed with the toilet, but unfortunately not for its intended purpose. No, her fascination stems from seeing how many things she can splash into the water before Jen or I discover what she's up to.

I should have known something was going on this afternoon when she readily agreed to go down for a nap without any fussing or fighting at all. I think I was just so relieved to actually have a bit of alone time that I didn't think twice about how odd it was that she was actually cooperating at the normally reviled naptime.

But sure enough, I hadn't been in the shower longer than a minute before hearing a splashy commotion; peeking out, I discovered that she had filled the bowl with all of my most important things.

DAY 400

I had such a great night's sleep last night — went to bed early and slept all night. However, when I asked Jen this morning why she looked so tired, she got unexplainably upset with me and said something like "Why don't you handle the bedtime routine this week if you think it's so easy?" as she stormed off.

OK, so the good news for Jen is that I figured out the problem as soon as I put Alice Bee in the crib tonight. Instead of going right to sleep like a normal person, she immediately starts screaming and crying and trying to escape.

Jen is going to be so happy when I tell her about the new bedtime routine I developed to combat Alice Bee's lack of cooperation. Equipped with noise-canceling headphones, a mug of chamomile tea, and the most fantastic love story ever told, I found myself able to completely ignore all the distractions and fell quickly asleep next to the crib.

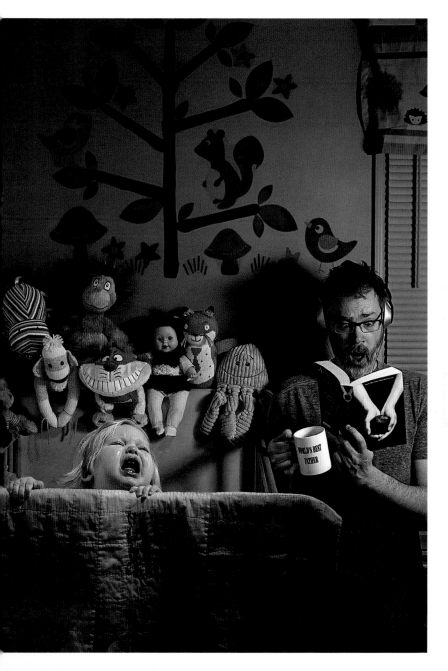

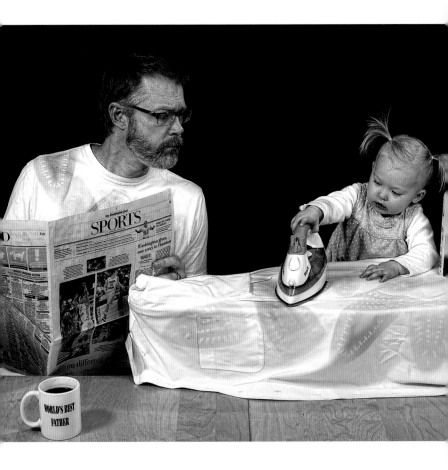

**DAY 407**

Jen wants me to start helping out with even *more* of the chores around the house. Not only am I expected to "pick my clothes up off the floor" and "flush the toilet," she's now telling me that she doesn't have time to mow the yard *and* get the clothes ironed and that I need to decide which one of these tasks I'm going to take on. This is going to seriously cut into my daily routine unless I figure something out.

**DAY 414**

Divvying up the chores has turned out not to be such a big hassle. The yard looks great thanks to Jen's mowing, and I still get to read the sports page thanks to Alice Bee's help with the iron.

DAY 419

Alice Bee saw a commercial on TV for some sort of doll that comes with scissors one can use to cut its hair — for ages four and up. She *really* wanted that toy, but Jen emphatically told her that she's just not old enough yet. It broke my heart to see Alice cry like that, but Jen's rules are the rules.

All week long, Alice Bee has continued to beg us to let her practice using the scissors, but her mother is standing firm on this. Even this morning, as Jen was on her way out to mow the lawn, she unequivocally told me, "Don't let Alice Bee play with those scissors!"

Luckily, I was able to come up with a brilliant solution that satisfied both Alice Bee's current hair-cutting obsession as well as Jen's directive. Clippers are definitely *not* scissors, and I needed a haircut anyway since Jen specifically asked me to look nice for tonight's military ball.

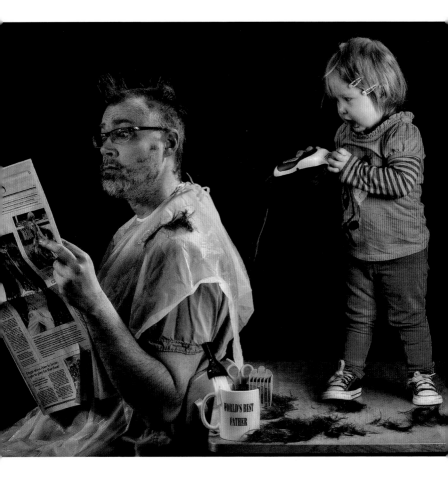

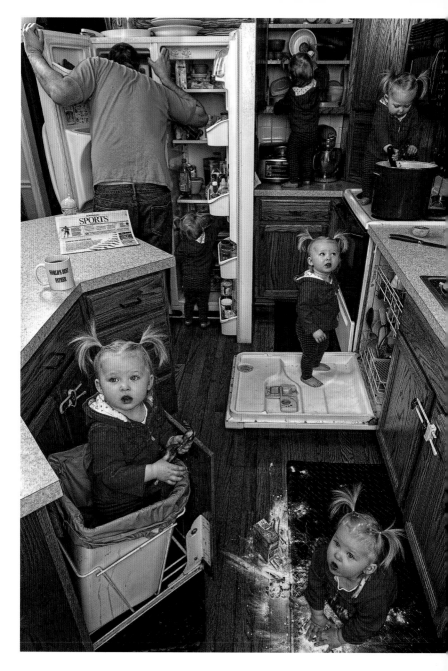

DAY 428

I always get in trouble for making a mess in the kitchen, even when it's not my fault.

Today is a perfect example. On her way out the door to go jogging, Jen told me to keep an eye on Alice Bee. Of course, Jen out of the house for forty-five minutes always means Dave gets ice cream for breakfast, so I quickly ran into the kitchen to check the freezer. I swear, I was only in there for, like, thirty seconds, but when I turned back around, ice cream in hand, I discovered that Jen had returned early and was standing in the doorway with her hands on her hips, the kitchen had been obliterated, and Alice Bee was sitting quietly in the living room playing with blocks. I have no idea what actually happened, but I still had to spend my entire morning cleaning the kitchen.

DAY 434

A misplaced stepladder combined with Jen's insistence that I replace all of the burned-out bulbs in the house today allowed me to finally answer the question "How many Engledows does it take to change a lightbulb?"

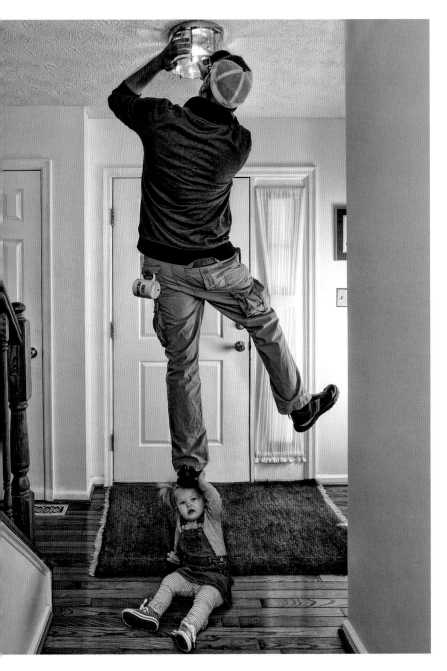

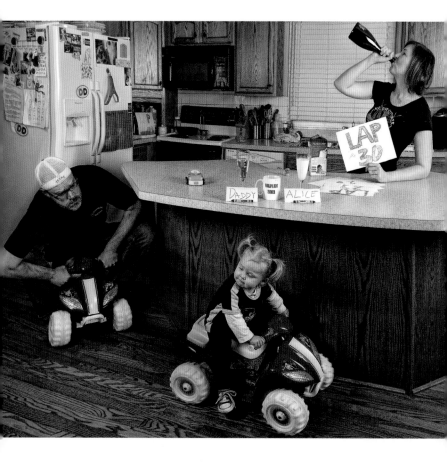

DAY 442

It appears that Alice Bee's relatives on both sides of the family really want her to become a racecar driver. Her California relatives mail our whole family brand-new Mr. Horsepower gear every single Christmas, and this year her Texas relatives bought us a set of matching princess cars.

I decided it was time to see if Alice Bee truly has the right stuff to succeed as a competitive racer, so we set up a five-hundred-lap race around the kitchen island.

Unfortunately, the race was called off around the fifty-lap mark, when we discovered that the World's Best Mother had prematurely finished all of the victory Champagne.

DAY 462

After our Kitchen Counter 500, Alice Bee has become obsessed with driving. This is good news for me, as she now spends hours every day on her car, giving me even more quality time with the sports page.

This morning, I heard a loud crash from the living room. Alice Bee had apparently attempted to ride her car down the stairs, resulting in a tiny gash above her left eye.

Since 911 no longer responds to my calls (long story), I took matters into my own hands and quickly gathered up some of Jen's sewing supplies.

The great thing about low-flow rubber nipples? They administer the perfect amount of whiskey to calm a toddler during surgery. Five minutes later, Alice Bee was as good as new and sober enough to pass a Breathalyzer test before getting back behind the wheel.

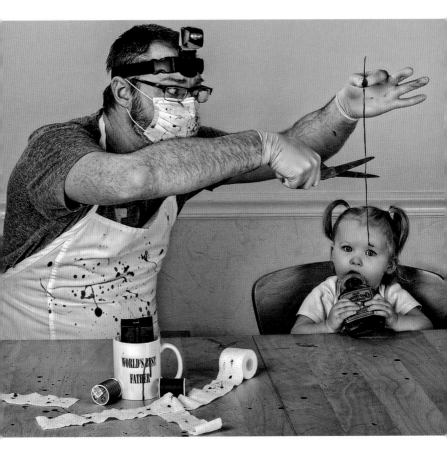

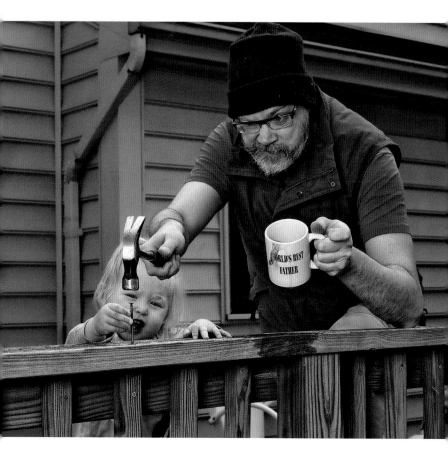

**DAY 469**

This morning Jen demanded that I finish building the deck I started constructing back when we first got married. I don't know what her problem is — eight years is a totally reasonable time frame for a project of this magnitude.

I guess part of the problem here is that I've always shied away from hammering things, mainly because any job requiring two hands is impossible to do while holding a cup of coffee. However, now that Alice Bee is around to help me get the nails started, I'm gonna be able to finish that deck in no time.

DAY 470

Easter! One of my favorite holidays — marshmallow bunnies, cream-filled eggs, jelly beans, and delicious, wonderful chocolate. I can never wait to see what Jen (I mean, the Easter Bunny) is going to bring me.

Imagine my surprise this morning when I bounded downstairs, only to discover that this year the Easter Bunny had decided to give Alice Bee *all* of the candy. For me, there was one single cream egg, with a not-so-subtle note attached reading, "Happy Easter, to my Chubby Bunny."

Fortunately, I convinced Alice Bee that she needed someone to "test" all her candy to make sure it was OK for her to eat. As I told her, you can never be too careful around candy delivered by an egg-laying rabbit.

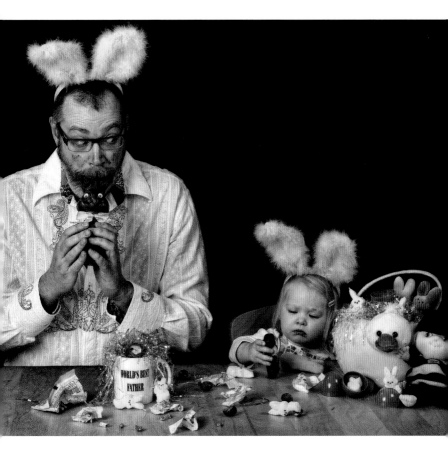

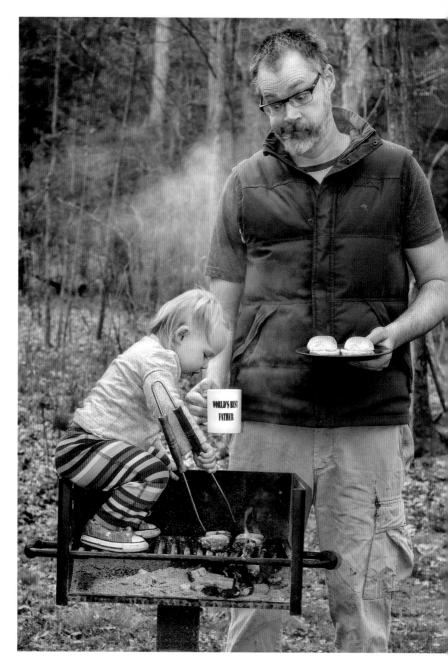

WORLD'S BEST
FATHER

DAY 477

This weekend we went on our first-ever family camp-out, which provided the perfect opportunity for Alice Bee and I to do some serious bonding.

To commemorate this new experience, I decided it was finally time to let Alice Bee light her own fire and cook over an open flame. Even though she begged me to make full-size burgers, we decided to go with the much more appropriately sized sliders for her first attempt.

I have to admit I had a tear or two in my eye when she placed that first, perfectly charred burger on my plate. But that was probably from all the smoke.

Jen is away on another out-of-town assignment. Her last words to me before hopping into the cab were "*Don't* forget to feed the cats this time."

All this time I'd just been assuming Elliott and Katje subsisted on lizards, mice, and baby birds.

After barely sleeping a wink due to nonstop caterwauling and cries for "ceweal" outside my bedroom door I finally dragged myself out of bed, even though it was only ten a.m. Despite the fact that all of this mewing and mewling was about to break my brain, I quickly filled up each of their respective bowls and sat down to finally have a cup of coffee.

It was only after Alice Bee started spitting up and saying, "I don' *like* it!" that I realized how similar cat chow and baby chow are in shape, size, and texture.

OK, I've got this down to a science now. Labels applied to all three bowls made the daily feeding routine a breeze.

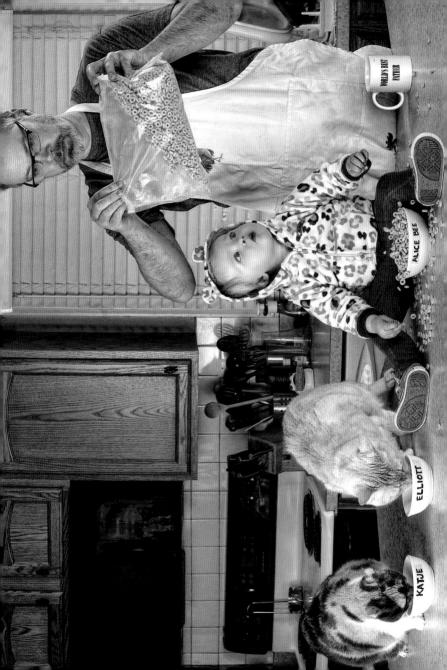

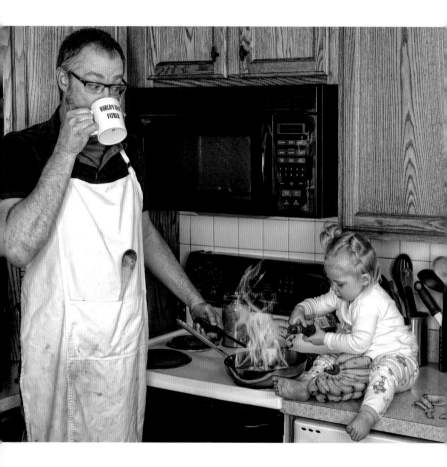

DAY 490

I've always dreamed about making Bananas Foster at home, but have never actually attempted it — mainly because flambéing, much like hammering, requires the use of both hands for an extended amount of time, severely limiting my coffee intake.

However, now that Alice Bee has experience cooking over an open flame and knows her way around a booze bottle thanks to our home surgery, I think we are finally ready to make this delicacy for ourselves. Although she has never tasted rum before, Alice Bee *loves* bananas and brown sugar, so I have no doubt she is going to freak out when she tries this.

DAY 498

Jen caught Alice Bee playing with the toaster again last night. After another thirty-minute lecture about how I am "ten months behind" on my promise to baby-proof the house, Jen finished by directing me to, at the very least, teach Alice Bee that the toaster is not a toy.

Taking Jen's directive to heart, this morning I carefully showed Alice Bee how to plug the toaster into the socket, walked her through how to drop the bread in and even how to perfectly butter each slice when it pops up.

I figured she'd enjoy this process, but I had no clue that she'd take the job so seriously. Apparently, her quality-control protocol requires her to test each piece before putting it on the plate. I have no idea where she got the inspiration to do that.

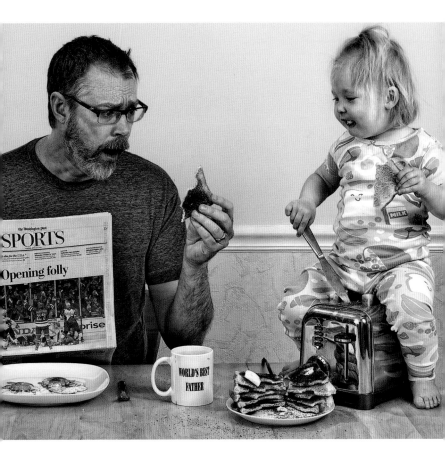

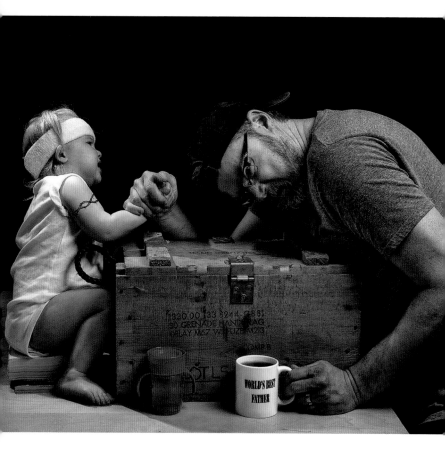

**DAY 504**

Today I decided it was time to remind Alice Bee that my authority deserves her respect. Since one of her all-time favorite Sly Stallone films is *Over the Top,* I figured arm-wrestling would be the perfect way to drive this point home. And I'm happy to report that I won three out of five matches, forcing Alice Bee to grudgingly admit that her old man is still the man.

I was so excited about my victory, I even drew up a household chain-of-command flowchart, with me on top. I don't think Jen really understands what I've created, because she keeps turning it upside down every time I show it to her.

DAY 527

Jen has finally gotten fed up with having to buy new clothes every time Alice Bee and I do the ironing, so we're switching chores and I'm in charge of the lawn this week.

I know from my own traumatic childhood experiences that a petrol-powered mower is definitely not the sort of thing an eighteen-month-old can safely operate, so I was truly delighted to discover that the mower we own is powered by electricity. Alice Bee has been operating electrical devices for months now, so running this new piece of equipment should provide little challenge for her.

It was pretty hot today, and Alice spent a good portion of the morning whining and pro-crastinating. I finally laid down the law and told her that I wouldn't give her any milk until the lawn was perfect. She ultimately got the yard looking gorgeous, but not before I had used the last bit of milk for my coffee. I think Alice Bee learned a valuable lesson today about the importance of finishing tasks in a timely fashion.

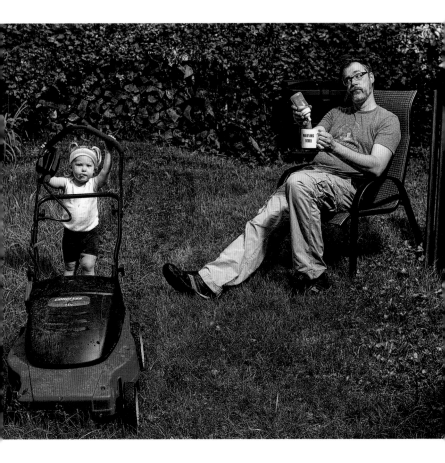

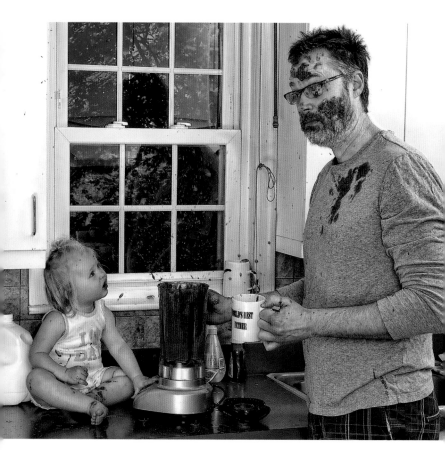

**DAY 532**

Last week I noticed that Alice Bee was really starting to drag after mowing the lawn. I know Jen is always talking about "replacing electrolytes" after she works out, so maybe this is something I need to consider for Alice Bee after future yard-work sessions.

I wasn't exactly sure what electrolytes were, but I'd heard that healthy people drink something called "smoothies," so I thought that might be a good place to start. A quick Internet search revealed that smoothies are just a bunch of fruit thrown in the blender, which seemed like the perfect pick-me-up for a kid with a crazy fruit obsession. Plus, teaching her how to use the blender for the first time would be fun for both of us.

I thought the new purple spots on the ceiling added a nice pop of color to our interior, but Jen was not nearly as amused by the outcome as were Alice Bee and I.

**DAY 539**

Terrible news — my favorite coffee mug is missing! I've searched high and low and can't seem to locate it anywhere.

And to make matters worse, Alice Bee has been complaining all morning about having a tummy ache, so I'm going to have to put off the search until I can figure out what's going on with her. She's been making a *lot* of smoothies lately, so I'm guessing she probably just got a hold of some bad fruit.

I guess the only good news is that I may finally get to test out my brand-new home X-ray kit I ordered through that late-night infomercial. Jen made fun of me at the time, but I'll have the last laugh when I start saving us serious money on our doctor bills.

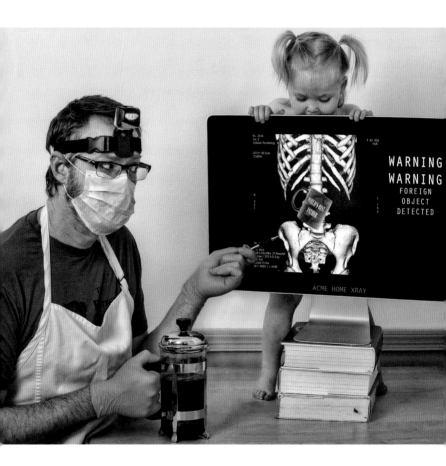

WARNING
WARNING
FOREIGN
OBJECT
DETECTED

ACME HOME XRAY

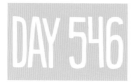
DAY 546

Today is Father's Day! Alice Bee totally surprised me by making breakfast in bed! Pancakes, maple syrup, even a fresh pot of coffee — she has really put to good use everything I've taught her these past eighteen months.

It was only after I was completely stuffed from breakfast that Alice Bee handed me a card from Jen that read: "Happy Father's Day. Just a reminder that my one-year tour in Seoul started today, which means you have moved up one slot in the household chain of command. Congratulations, and good luck!"

So, yeah. Father's Day rules.

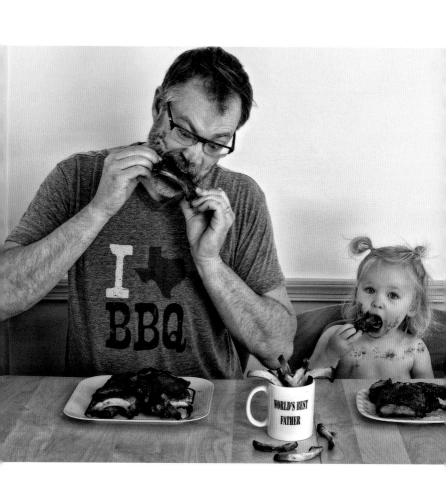

**DAY 555**

Nine days since Jen left. This officially marks the longest period of time that Alice Bee and I have been on our own without Jen, but I think we're doing OK. We made ribs yesterday. And we made ribs the day before that . . . and the day before that . . . and the day before that . . . and the day before that . . . and the day before that . . . and the day before that . . . and the day before that.

We're having some real quality father-daughter bonding — it's so nice to see that Alice Bee loves barbecue as much as her old man.

DAY 566

Of all the tasks I now have to take on while Jen is away, none is more difficult or challenging than getting Alice Bee dressed and ready for school. Putting clothes on a wiggling, head-strong twenty-month-old child is akin to filling a saltshaker through the top holes while log-rolling on the deck of a ship in the middle of a typhoon amid a band of screeching howler monkeys attempting to rip your clothes from your body.

This daily battle of wills generally comes down to creative differences between the two of us. I, for example, think she should wear clothes to preschool. Alice Bee, on the other hand, thinks clothes are for chumps. I think she ought to wear *two* socks (one on each foot); Alice Bee thinks one sock is plenty.

However, I think that we have finally reached an accord. I bribe her with whatever sweet treat she wants, she begrudgingly lets me select one item for her to wear, and then she gets to pick out the rest.

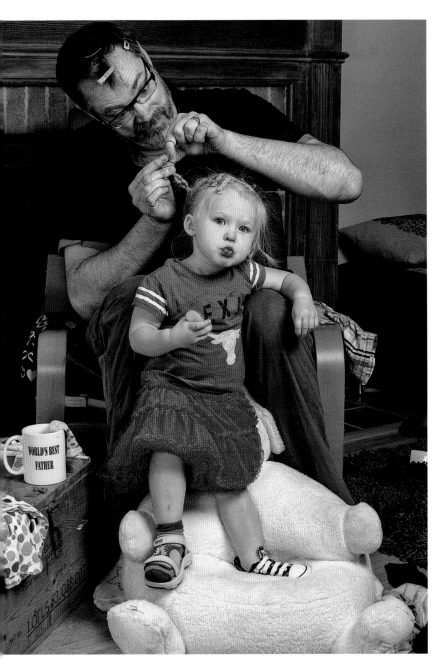

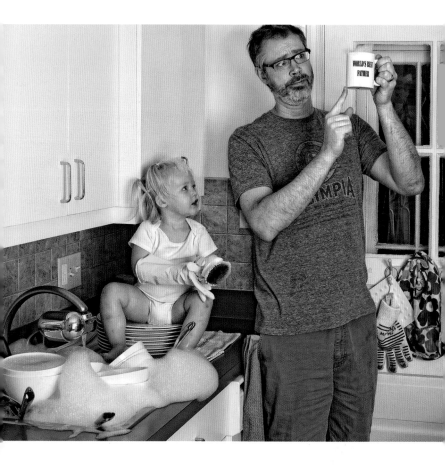

DAY 574

I've always been very conscientious about making sure I put my dirty dishes in the sink — I know this is what's required for them to get clean. I've also been diligent about teaching Alice Bee to do this too, since her mom is not here to pick up after her. The weird thing is that we've both been very focused on this since Jen left for Seoul, but each morning when we wake up, the dishes are *still* there in the sink, dirtier than ever.

When I mentioned this phenomenon to Jen during a video chat yesterday, she just rolled her eyes and said, "How exactly do you think those dishes get clean and put away after you put them in the sink?" I was hoping she would actually answer the question, but we must have had a bad connection because the screen went dead and she didn't pick up any of the times I tried to reconnect with her.

Serendipitously, while playing under the sink this morning, Alice Bee discovered what appear to be dishwashing implements. Alice Bee on scrub detail, Daddy on quality control — we made a great team.

**DAY 580**

Alice Bee loves Pizza Night. And while Jen is away, I've been teaching her every aspect of making the perfect pie. Last week, I showed her how to toss the dough and make homemade tomato sauce, and the week before that she mastered using the peel to quickly get the pizza in and out of the oven.

Tonight we're going to work on presentation — I know Alice Bee is really excited about finally getting to use the shiny pizza cutter (or, as she calls it, "da circle knife") that has fascinated her since she was a baby.

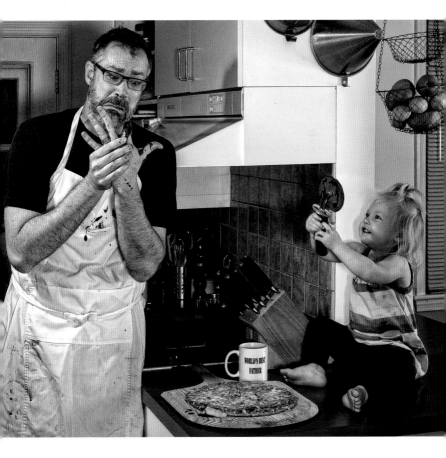

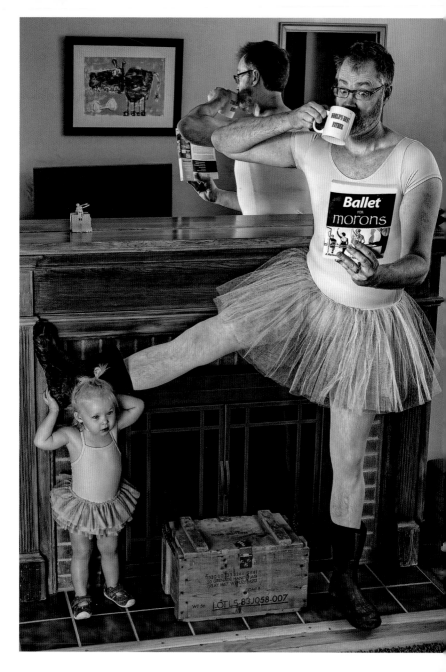

DAY 588

Earlier this week, Alice Bee bet me that I couldn't perform something called a "grand-jeté" — winner gets either five fruit cups or five nights of no-fuss bedtime. Even though I had no idea what she was talking about, I instantly took the bet; since Jen left, Alice Bee's nightly bedtime routine includes hours of kicking, screaming, and sobbing — and Alice Bee behaves pretty poorly too.

It turns out this grand-jeté is some sort of complicated ballet thing. I knew I'd need to properly equip and prepare myself, so I purchased the perfect instruction manual and ballet outfit.

These ballerino moves are not as easy as they look, especially since I am a bit out of shape. The good news is that Alice Bee is now the perfect height to assist me in my training. Five nights of no-fuss bedtime, here I come!

I've decided that it's time for Alice Bee to start mastering a sport. And with only four years until Rio, Alice Bee's really gonna need to get over her fear of heights if she's to have any shot at all of making the 2016 diving team.

When Jen learned about the water damage from our diving training, she expressly forbade me from letting Alice Bee practice her diving in the house anymore. We're going to need to find another sport for Alice Bee to master since the local dive center claims that Alice Bee is "too young" to jump off the high-dive.

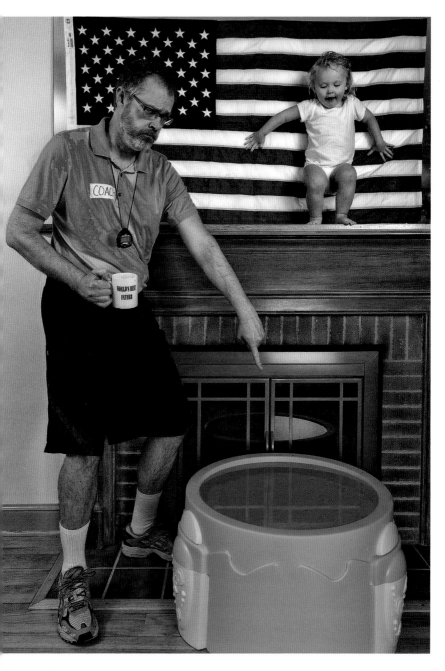

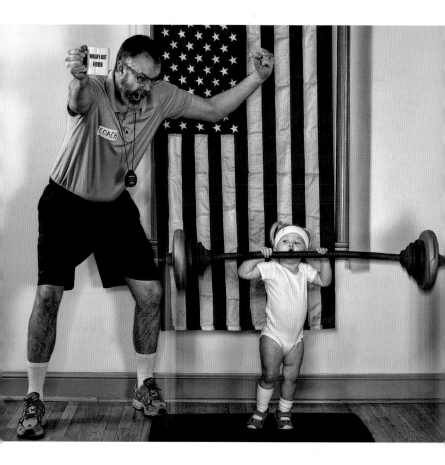

**DAY 600**

We have a new sport! While playing in the crawlspace earlier this week, Alice Bee discovered an old set of weights, and we are now in our fifth day of training for the clean and jerk. I'm pretty sure Jen will approve of this new event. I don't have to spend any more money out of the joint account to fund it, and since there's no water involved, our hardwood floors should be safe from any additional damage.

DAY 614

At preschool pickup today, one of the teachers was extremely upset and informed me that Alice Bee had repeatedly used the expression "son of a poop" during playtime and had even called one of her teachers a "mother dump-trucker." Glaring at me accusingly, this teacher suggested that it might be in Alice Bee's best interest for us to incorporate something called a "swear jar" at home.

Having never heard of this "swear jar," I had to look it up online. Apparently this is some sort of New Agey concept invented in recent years to help keep *parents* from swearing in front of their kids. WTF? I spent my youth getting my mouth washed out with soap for swearing and now have to spend my adulthood paying a financial penalty to my own child every time I curse? This is so mother dumptrucking unfair.

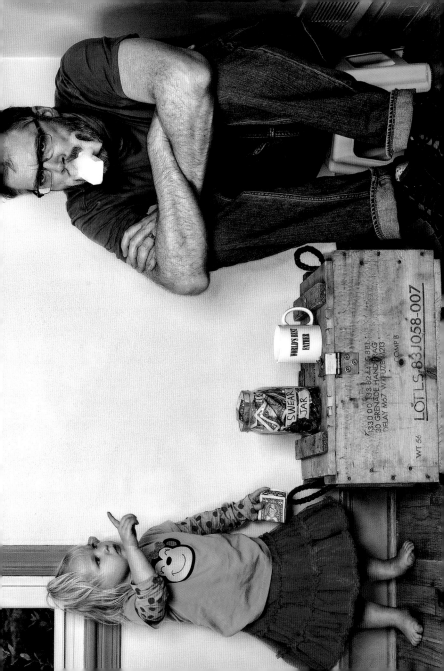

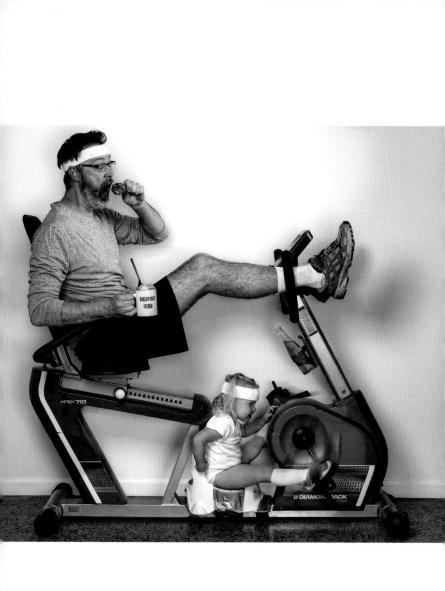

**DAY 634**

Jen keeps bugging me to work out more while she's away and today is the day I've decided to start my exercise regimen. Alice Bee spends a lot of her time down in the basement, and reminded me this morning that we have an old stationary bike down there. This seems perfect, because I won't have to spend any additional money on an exercise program we all know I'm only going to do for a few weeks until Jen forgets about it.

I hadn't anticipated how much Alice Bee has grown — she's big enough now to serve as the perfect workout partner. Not only did we ride fifteen miles today, I was even able to enjoy some of Alice Bee's famous fried chicken and a tasty beer while doing so. I may have finally found an exercise routine that I can stick with, and Jen's sure to be impressed by all the virtual miles I'll put on the odometer.

Over the past several weeks, my cookies have mysteriously disappeared from the cookie jar each night. This morning, I finally put it all together while reading through the local police blotter. I was disappointed to learn the cops still have no leads in the case of the local cat burglar who has been robbing our neighborhood blind, and then it hit me — it's that cat burglar who's been stealing all my cookies!

After spending more than five fruitless hours at the local police precinct trying to explain my theory to anyone who would listen, I have decided to take matters into my own hands by searching for clues to support my theory. I was a little surprised that Alice Bee didn't want to go with me to the police station, but I'm sure she'll be really proud of her old man once I've collected enough evidence to finally put that cat burglar behind bars for good.

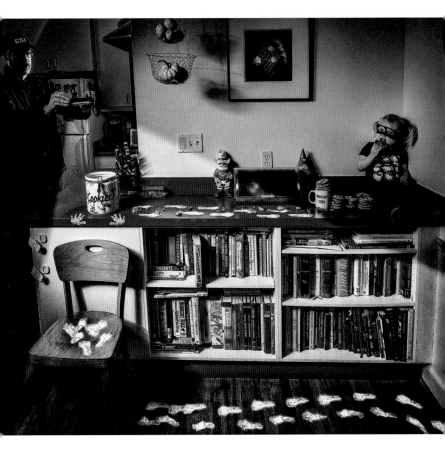

DAY 648

Unbeknownst to me, Alice Bee has secretly been posting our family photos online for several months now. Apparently, the images went viral last week and have now been seen all over the world.

Things got so crazy that Alice Bee and I were even invited to appear on the *Today* show earlier this week. Meeting Matt and Savannah was pretty cool, but our appearance was marred by Alice Bee's continued attempts to escape the stage during the live broadcast.

Now that we're safely home from NYC, I am having Alice Bee review the video of her performance and write a five-hundred-word essay on how to comport herself on national TV.

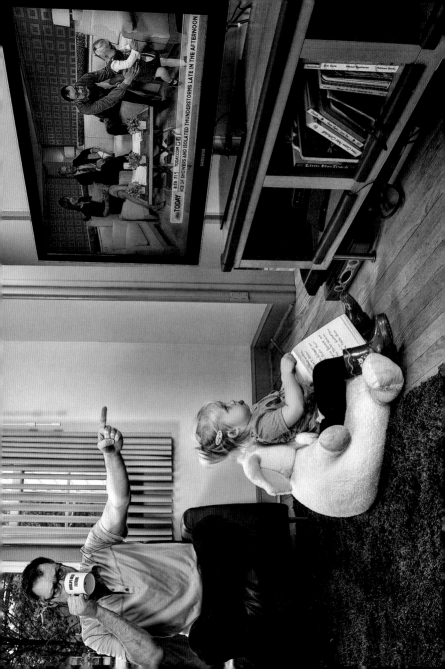

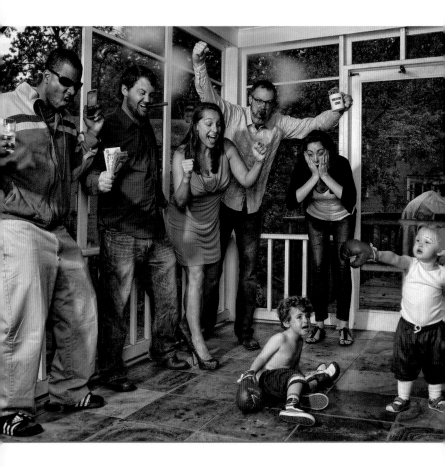

DAY 655

Since Alice Bee was born, I have seen a shocking decline in the amount of time I spend hanging out with my cooler (i.e., childless) friends. Instead, I now spend most of my free time on "playdates" with Alice Bee.

Playdates suck. The kids always end up ignoring or fighting one another and there are never any cool (i.e., childless) people to talk to.

The good news is that I have developed a plan to change all of this: Playdate Fight Club! Since playdates inevitably lead to bad blood on some level, why not cash in and make things more interesting?

Now when Alice Bee gets bored and picks a fight, rather than apologizing to the other parents, I can take their money instead. And, most important, my cool friends are starting to come back around.

**DAY 663**

Alice Bee's newfound interest in pretend play couldn't have come at a better time. She always wants to play "store", and I need someone to take care of my feet while Jen is away.

"Pedicure Store" may be the best game I've ever invented. Not only do I get a much-needed service, I can also pay for said service with pretend money. Perfect in every way.

Today was her first attempt at this game, and I gotta say, she did a pretty damn good job with all of my calluses; however, I'm still a bit dubious about her choice of nail polish.

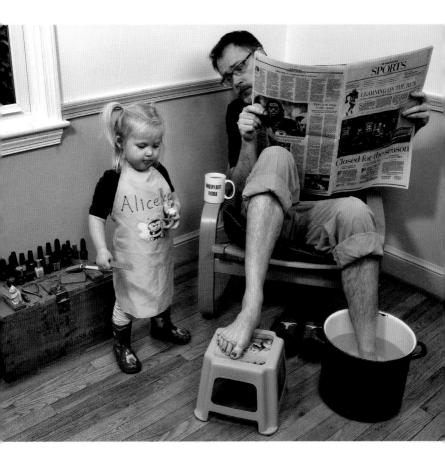

**DAY 669**

One of the worst aspects of single parenthood is the complete and utter lack of privacy and alone time I now have. It's like Alice Bee has a sixth sense — this uncanny ability to instantly recognize my need to be alone, and homing pigeon–like skills at pinpointing my exact location.

Even my sacred morning trips to the "reading room" are inevitably interrupted by a pounding on the door and shouts of "Daddy, I need go potty NOW!" Luckily, my lessons about sharing are starting to take hold, and Alice Bee is perfectly content to take care of business from the upper deck.

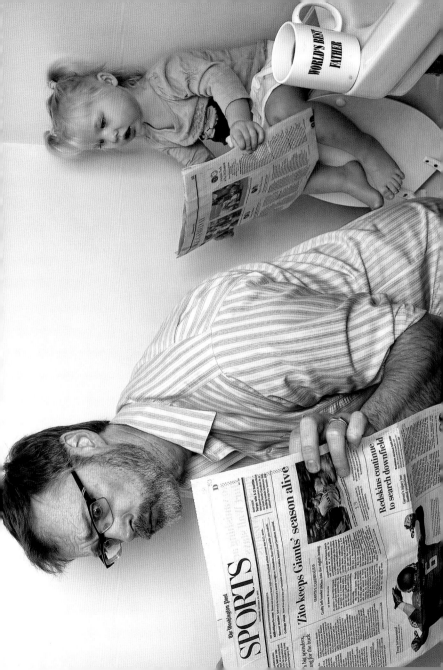

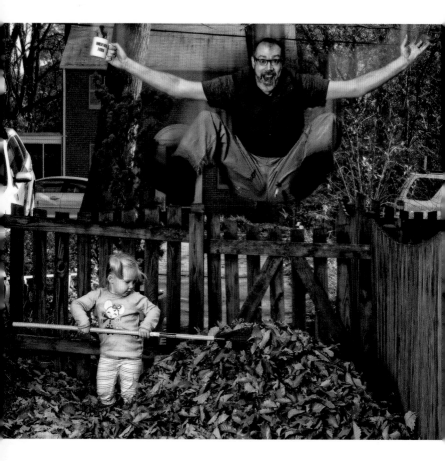

I love the fall: college football, the wonderfully crisp air, the beautiful colors of the trees, and college football.

The only downside is raking all of those leaves — Jen normally takes care of this while I'm watching football, but she's not here this year. Luckily for me, I now have a little helper to assist with these types of activities.

Alice Bee was super-excited when we found a child-size rake at the hardware store today and she had a great time building up some truly massive leaf piles. She got a bit frustrated that some of her more inviting piles got jumped in during halftime, but that's all part of the beauty of autumn.

**DAY 701**

It's Thanksgiving and once again time to prepare and devour massive amounts of turkey. Alice Bee has been bugging me for weeks to try something different from our traditional smoked bird, so I finally gave in and let her spend her allowance on a new turkey fryer. Kenneth, my redneck brother back in Texas, does this every year. How hard can it be?

Alice Bee did a pretty good job getting the fryer set up while I was watching football on TV, but as usual, her attention to detail was a bit lacking — not only did she neglect to fill the fryer all the way to the top with peanut oil, I even caught her earlier in the day trying to defrost the turkey. Everyone knows the best way to seal in the flavor is to drop the frozen bird directly into the bubbling oil.

**DAY 701**
**(PART 2)**

OK, Alice Bee was right. We should have thawed the turkey first. And how was I supposed to know that putting water on a grease fire would make it worse? Luckily, Alice Bee had her fire extinguisher handy and was quickly able to douse the flames.

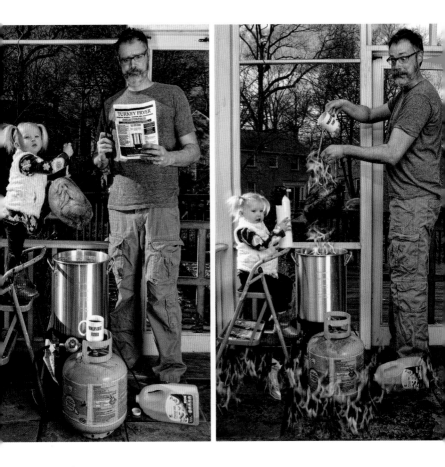

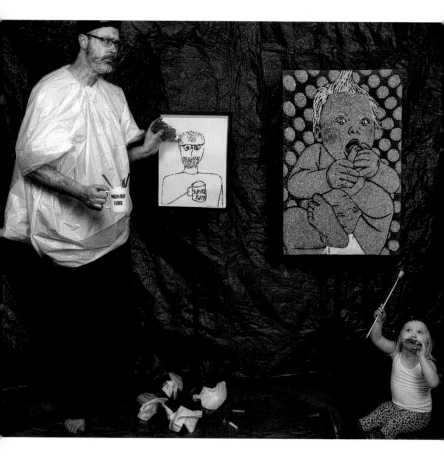

DAY 726

We are going to Seoul to see Jen in two days! Alice Bee is really excited and suggested that the two of us should make some sort of art project to bring to Mommy as a present.

After much debate, we finally settled on glitter-art self-portraits. I have to say that I'm a little worried that Alice Bee's self-confidence may take a hit when I unveil my masterpiece. I mean, I'm sure Jen will pretend to love whatever childish attempts Alice Bee manages to put down on canvas, but I totally kick ass when it comes to making art projects, and I am a certified glitter-glue virtuoso.

DAY 728

Alice Bee and I arrived in Seoul today and Jen picked us up from the airport. When I asked her if she was sure there'd be enough room in her Army tent for me and Alice Bee, she reminded me that she wasn't assigned to the 4077th and that we would be staying in her modern furnished apartment right in the heart of the Itaewon District.

As excited as Alice Bee was to see Mommy and learn that we would have an actual roof over our heads, she was more than a little disappointed about the location of the apartment — I think she secretly hoped we'd be in the Gangnam District, where her favorite dance originated.

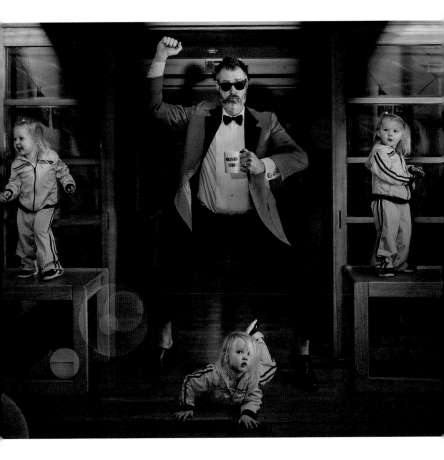

DAY 734

This Christmas, my mom really knocked it out of the park. Not only did she actually figure out how to ship our presents to Jen's apartment in Seoul, she scored a home run with the gifts she bought for our family this year.

First of all, she bought me and Alice Bee these kickass matching "World's Best" T-shirts. The two of us are going to look so cool walking around Seoul together.

Jen, who is very hard to buy for, initially seemed less than pleased with her present, but cheered up a bit when I reminded her that nothing says "World's Best Daughter-in-Law" like a new pair of tube socks.

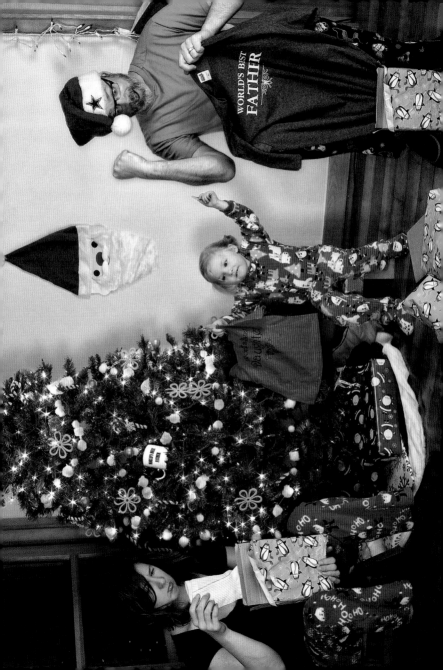

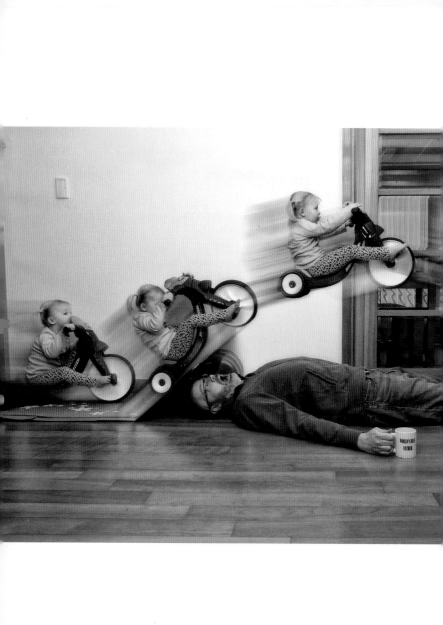

DAY 735

After Alice Bee's failed attempts to ride her princess car down the stairs earlier in the year, Jen confiscated the vehicle, telling Alice Bee that she needed to wait until she was older.

It broke my heart to see how sad the Bee was without her car, but since Jen told me she'd confiscate *my* car if I gave Alice the keys back, my hands were tied. As a consolation, we found some vintage Evel Knievel videos online and she has spent the past six months obsessively watching them over and over.

The really great news is that Jen seems to have been infected with the Christmas spirit; she bought Alice Bee a brand-new foot-powered three-wheeler — perfect for riding around on the heated floors of the Seoul apartment. Alice Bee pulled me aside and told me that as soon as Jen leaves for work on Monday, she wants me to help her with a couple of "Evel Bee-Nievel"–style stunts. I can't wait!

**DAY 737**

I don't think I was prepared at all to deal with the spiciness of the food here in Seoul.

Today, for example, when I asked Alice Bee to cock me some lunch, she quickly assembled a meal from items in Jen's pantry: spicy kimchi, long peppers dipped in *ssamjang* and a bowl of Shin Ramyun Black.

Everything was delicious, but Jen was pretty upset when she returned home from work to discover that we had finished off an entire week's worth of her drinking water.

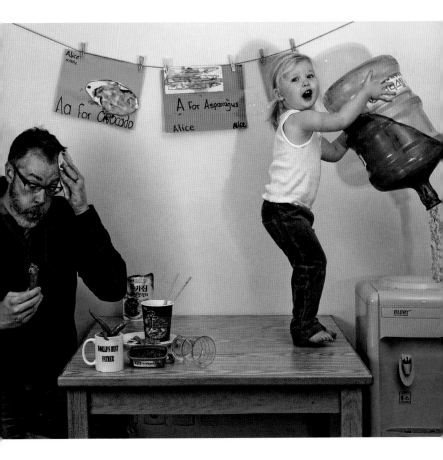

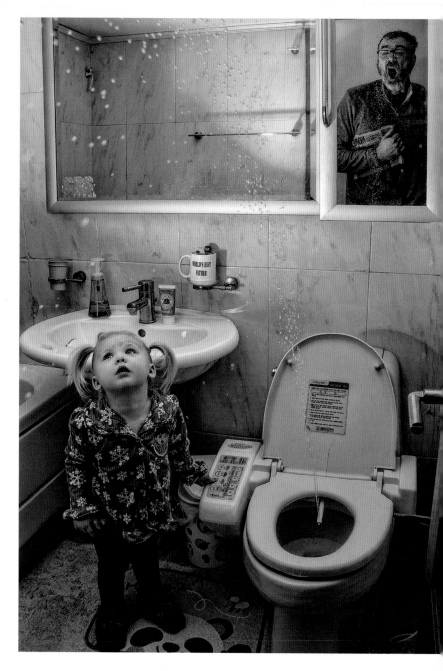

The best thing about Jen's apartment in Seoul? The fancy toilet with all of its flashing lights and mysterious buttons.

The worst thing about Jen's apartment in Seoul? The fancy toilet with all of its flashing lights and mysterious buttons.

DAY 743

Last night Jen freaked out when she saw Alice Bee sitting on the counter next to the sizzling pan of *bulgogi* we were preparing for dinner. She even refused to listen when I assured her that we'd been cooking like this back home for months now.

At first I thought this arbitrary and unnecessary new rule was going to hamper Alice Bee's ability to help prepare our meals, but this morning at breakfast I finally understood Jen's logic about banning Alice Bee from the counter — the range hood is indeed a *much* safer place for Alice Bee to hang out.

Our eggs contained a bit more shell than normal this morning, but I'm sure it'll just take her a couple of meals to figure out how to effectively assist from this new perspective.

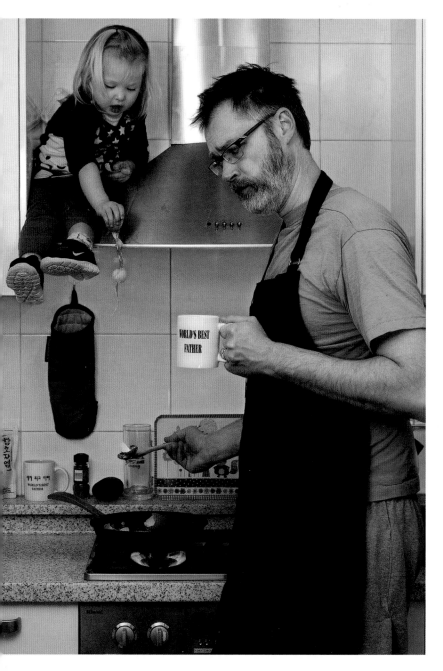

DAY 744

Jen and Alice Bee have been doing a lot of yoga together during our stay here in Seoul. Every day, the two of them get together and do weird animal poses like "downward-facing dog" that are so impossible-looking, my back hurts just from watching.

However, Alice Bee's obvious enthusiasm for this form of exercise and the quality time she and Jen share during this daily routine have piqued my curiosity, and today I cautiously agreed to let Alice Bee try to teach me a few things.

It turns out that yoga isn't actually that hard. By the end of our session, I was even inventing new poses, including my soon-to-be trademarked signature move — the one handed firefly.

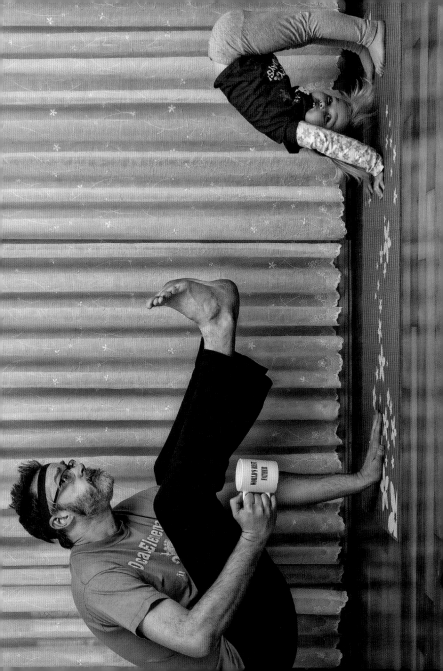

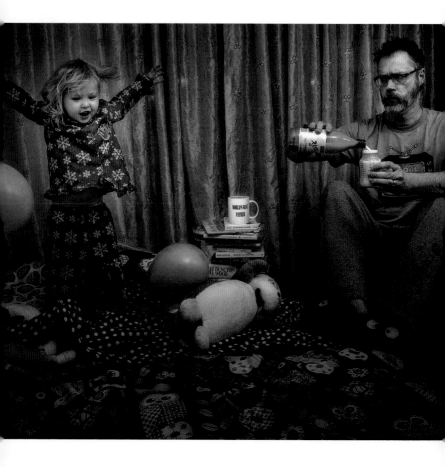

DAY 747

The bedtime routine here in Seoul is proving to be an even bigger challenge than at home. Not only is the time difference messing with Alice Bee, but her transition to a big-girl bed means that she is now able to escape with relative ease.

Tonight was awful. Six trips to the potty, three bedtime snacks, seven books read (including the first unabridged Game of Thrones novel) and Alice Bee was still showing no signs at all of going to sleep.

I was hoping some warm milk would calm her down, but we were out. I found a green bottle of something called *makgeolli,* which I assumed was the Korean word for "milk". I poured Alice Bee a big bottleful, and she was asleep in no time.

I later learned that *makgeolli* is actually an alcoholic beverage made from fermented wheat and rice, which gives it a milky appearance. Bedtime should be a breeze from now on!

**DAY 748**
**9:00 A.M.**

These late nights are seriously cutting into family time — with my online guild. We have slain significantly fewer Orcs (and only one dragon) since my arrival in Seoul and some of the other Elves are starting to grumble.

Since Jen has forbidden me from using the *makgeolli* trick again, I think I'm going to try to make use of one of the cooler features of the apartment — the glassed-in side-porch balcony that surrounds the entire living area. It is significantly colder than the rest of the apartment, but it's also completely soundproof.

**DAY 748**
**11:00 P.M.**

The side-porch balcony worked like a charm for Alice Bee's "camp-out." A few boxes of raisins, a fresh bowl of water and a sleeping bag for warmth bought me several hours of undisturbed dungeon-crawling.

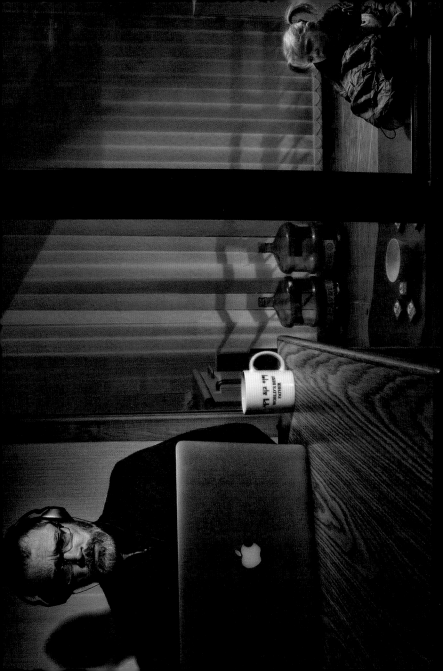

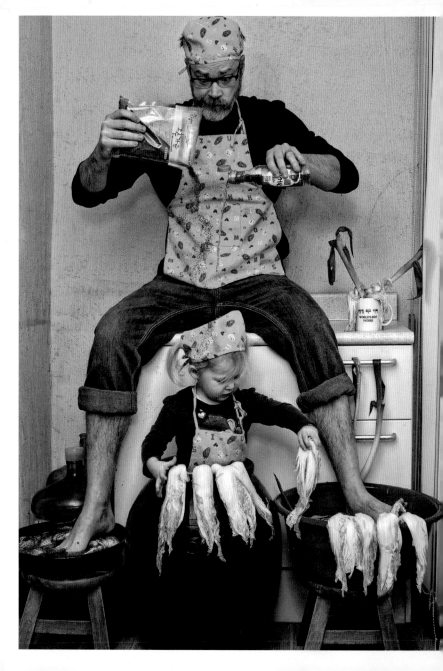

**DAY 751**

I'm finally getting used to the spiciness of the food here, and have developed a fairly serious addiction to the kimchi.

Well, today I had a surprise in store for Alice Bee. I bought us a brand-new kimchi pot and everything we'll need to get started making a big homemade batch of our own.

Alice Bee proved to be invaluable in our kimchi-making process. Not only did she do an excellent job of soaking the cabbages and scallions, having her serve as my assistant meant that I was able to keep my own hands completely free of the strongly scented fish sauce and the burning from the *gochugaru* (red-pepper powder).

**DAY 755**

Last night, Jen started bugging me again about making sure that Alice Bee eats all her veggies at lunchtime. And as if able to read my mind, she was quick to remind me that jelly beans aren't actually vegetables and, regardless of what the Reagan administration had determined when we were children, ketchup is not considered a side dish in our household.

I will admit that I've probably been a little lax in my enforcement of this particular rule. It takes Alice Bee *forever* to finish her lunch, particularly when it comes to something like peas — a food that, based on its temptingly perfect size and shape, often finds its way into her nose rather than her mouth. Plus, a busy guy like me definitely doesn't have the time to turn every mealtime into an hour-and-a-half battle over nutrition.

The good news is that I now have this situation totally under control. Installing video chat on all our devices should easily allow me to take my parenting skills to the next level. Even when I'm updating my status or checking sports scores online, I can still make sure Alice Bee eats all her peas.

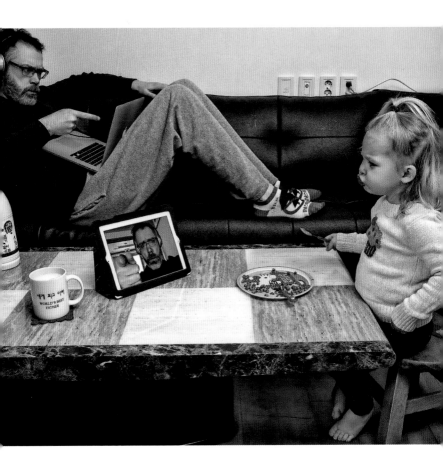

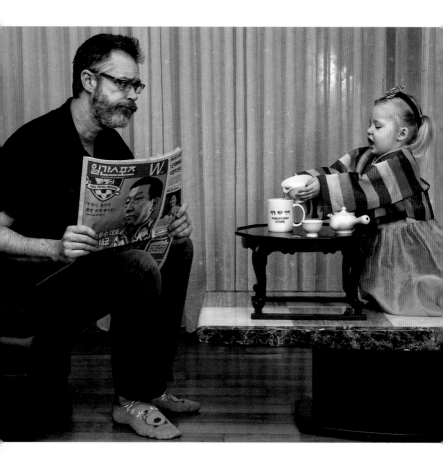

DAY 758

Whenever we travel, Alice Bee always makes a point of trying to embrace the local culture.

So, instead of bringing me a fourth pot of coffee every day like she'd do back home, Alice Bee now insists that we honor the traditional Korean tea ceremony each afternoon — she even dresses in *hanbok* (traditional Korean dress) before beginning the ceremony.

I was a bit dubious at first, but I have to admit I'm starting to find the whole process quite relaxing. She meticulously rinses the tea leaves and places them in the decanting bowl before carefully covering them with hot water. And to top it all off, she even brings me the local sports page to peruse while we wait for the green tea to cool to the perfect temperature.

DAY 760

Tomorrow Alice Bee and I head to the Seoul airport to begin the long journey back home. I get the sense that Jen is really going to miss having us around, mainly because she is putting on a big show about all the things that allegedly went wrong while we were here: how gross and dirty her apartment is, how angry the landlord is that we broke her fancy toilet, and the fact that the entire apartment smells like half-fermented homemade kimchi. I know this is just a defense mechanism to hide the fact that she's really going to miss us.

But just in case there is some small kernel of truth to these complaints, I decided to have Alice Bee clean the entire apartment while Jen is at work today.

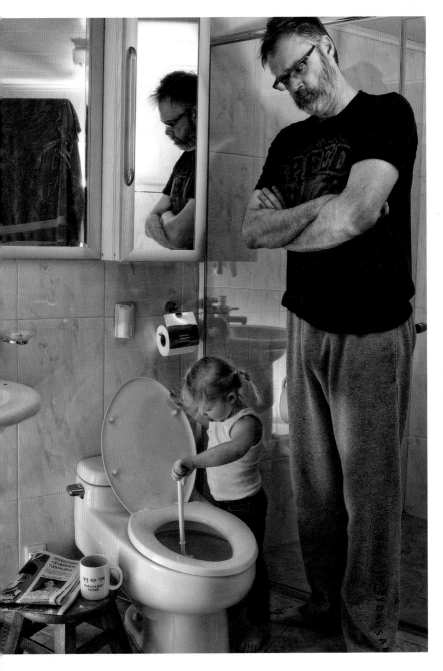

DAY 772

Alice Bee and I arrived back home safely and our weekend routine has pretty much returned to normal. She watches her programs during the day, and I watch mine at night.

Today was the biggest football game of the year and I was really looking forward to the change in routine. A 6:30 p.m. kickoff would provide the perfect opportunity for sharing, the two of us watching TV together as a family. I spent all afternoon getting ready — researching stats about the players online, chilling my beer, even popping up a super bowl of popcorn.

At exactly 6:30 I sat down in front of the TV, ready to bask in sporting bliss. Unfortunately, I discovered that Alice Bee was in the middle of a marathon of her favorite cartoon and she refused to change the channel. Not only that, she also got into my pre-chilled beer, which significantly increased her level of belligerence.

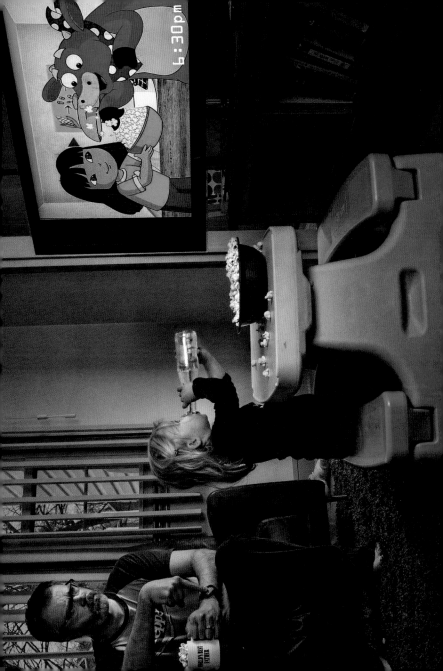

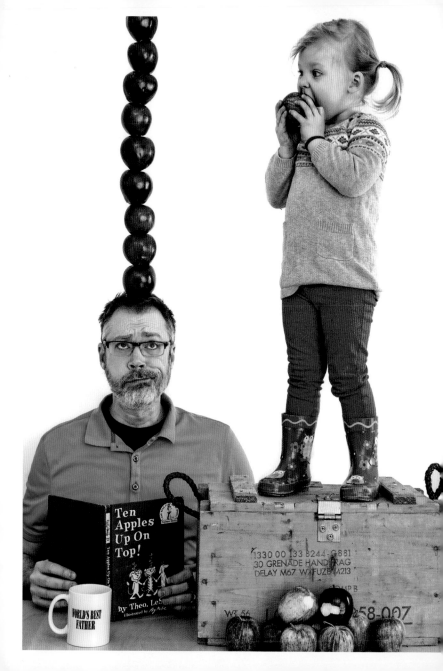

**DAY 792**

I really don't like most of the books Alice Bee asks me to read to her before bedtime. Half of them have no discernible plot at all — eight pictures of bunny rabbits is *not* a story that anyone cares about. Or they have plots that are so highly implausible, I have to force myself not to roll my eyes.

There is one book, however, upon which Alice Bee and I totally agree — *Ten Apples Up On Top!*, one of the earliest books written by Dr. Seuss (before he even became a doctor). I love the fact that it unabashedly stresses fierce competition among friends. Alice Bee likes it because it features apples.

**DAY 808**

I am not getting any sleep at night — Alice Bee's nighttime antics just get worse and worse, and I feel like genetics may play a role here. In my twenties, I was the type of guy who rarely if ever left a party before it was over — if I wasn't the last person to leave, there was always the chance I would miss something cool or amazing right after I walked out the door. I believe Alice Bee follows a similar philosophy about bedtime, as she is constantly making excuses and finding reasons not to go to bed, especially when she knows that other people in the house are still up and having fun.

And even after I've finally gotten her to fall asleep, the fight is still not over. She has developed the really bad habit of getting out of bed and coming to wake me up at all hours of the night.

I have a plan, though: I'm pretty sure that once I've convinced her the monster in her closet is real, she'll stay in her bed all night and let me sleep in peace.

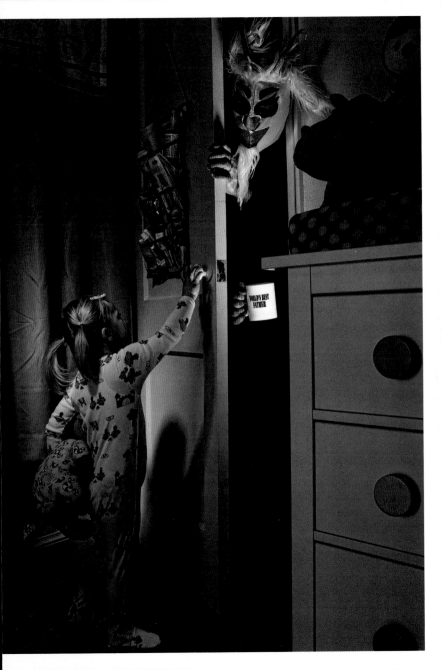

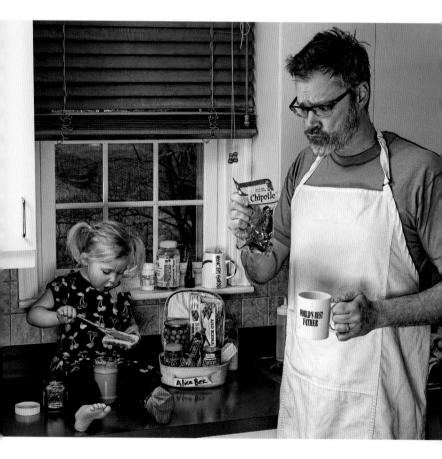

DAY 823

I've never really paid much attention to what's supposed to go in Alice Bee's lunch box. All I know is that she packs it up the night before, and I make sure she has it when I drop her off each morning.

Yesterday, however, I received a phone call from the principal of Alice Bee's preschool wanting to know why I hadn't responded to any of the notes about the contraband in Alice Bee's lunch box. When I explained that Alice Bee hadn't given me any notes, the principal informed me that my daughter had been packing *peanut butter* sandwiches in her lunch. She told me that in the preschool world this is an offense on par with biting or not sharing, due to the steadily increasing number of kids with severe peanut allergies.

So today was my first time packing Alice Bee's lunch, and I'm pretty sure I nailed it. I even made sure she'd have enough chipotles to share with all of her little friends.

DAY 830

I can't believe Easter is already here again! Since our regular, calorie-counting Easter Bunny is currently on assignment to the Asian continent, my portion of chocolate bunnies and cream-filled chocolate eggs dramatically increased from last year.

Alice Bee was also very excited when she came downstairs and found all of the brightly colored eggs that had been hidden around the house just for her. I have it on good authority that our substitute Easter Bunny stayed up late last night making sure that all of Alice Bee's eggs were perfectly dyed. Unfortunately, the regular Easter Bunny forgot to remind the substitute Easter Bunny to boil the eggs first.

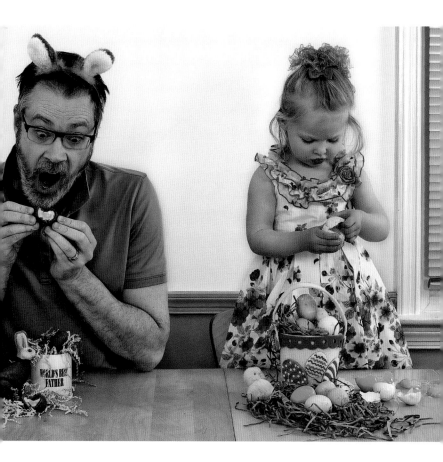

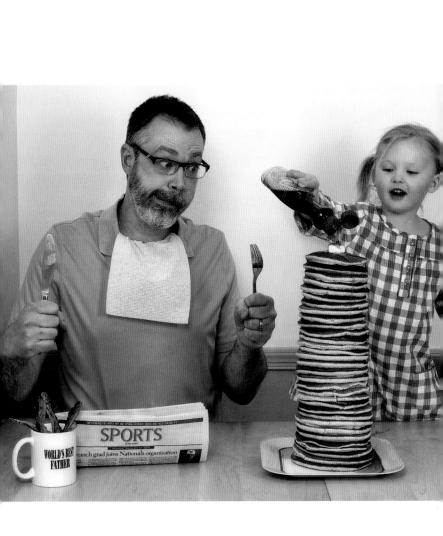

**DAY 837**

Alice Bee is really becoming a whiz in the kitchen. She's still not allowed to sit on the counter while cooking (we're doing our best to honor Jen's rules), but it doesn't matter because she's now tall enough to reach the burners by standing on the oven door.

This newfound freedom in the kitchen has inspired a bit of a culinary renaissance around our house. Alice Bee's attention to detail and focus on achieving perfection in the kitchen remind me a lot of myself when I was first learning to cook. To paraphrase *my* old man, she really is a chip off the old cow.

Today provided the quintessential example of how dedicated she is to perfecting her craft. I think most home cooks would probably be satisfied with pancakes that are *almost* perfectly round, but not Alice Bee. No, she kept pouring, flipping and stacking those johnny—cakes until she got one that was perfect enough to accurately calculate pi.

By the time she was done, I was faced with the largest stack of flapjacks I'd ever tackled — it took five hours, three bottles of syrup and an entire roll of antacid, but we eventually ate them all. And every last one was delicious. I really love that kid.

I really don't mind paying taxes. I figure it helps make up for all the street signs I stole as a kid and all of the (fake and real) 911 calls I make. Plus, being able to win any argument with my lieutenant colonel wife by saying, "Oh yeah? Well, my taxes pay your salary!" is reason alone to smile each year when the taxman comes a-calling.

Jen normally prepares our yearly returns, but this year Alice Bee has agreed to pick up the mantle since Jen is away. And the really good news? According to Alice Bee's calculations, I should be receiving a significant refund this year! I wasn't even aware that we could claim Katje and Elliott as dependents, but Alice Bee has studied the tax code and swears it's legal.

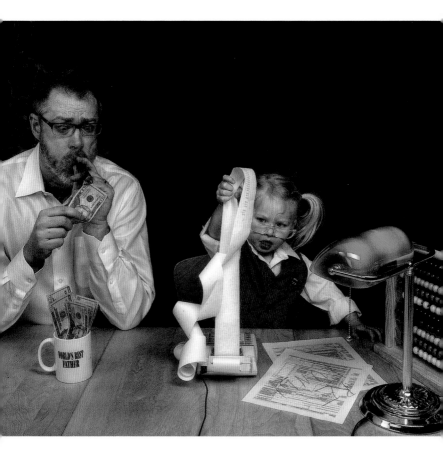

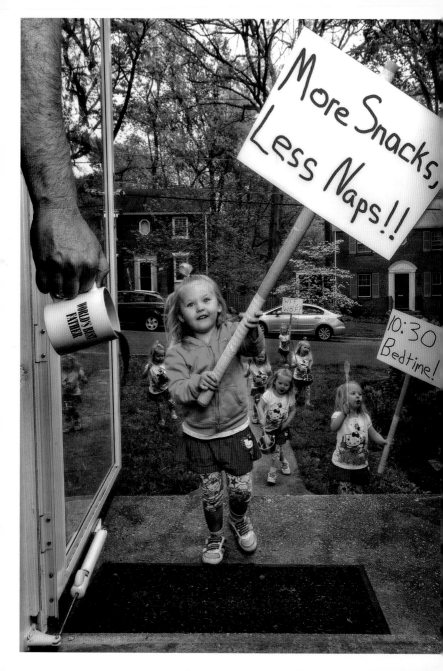

**DAY 861**

When I took Alice Bee to work with me last week, we passed by a bunch of protesters in Lafayette Park. She was immediately intrigued and started asking me all kinds of questions that I had no idea how to answer. I encouraged her to go talk to the organizers directly if she really wanted to know more and promptly forgot about the whole thing.

This morning I woke to chants of "No Justice, No Peas!" outside my front door. Citing numerous violations, including forced mandatory naptime and an hourly fruit snack rate that falls well below the legal minimum standards, Alice Bee decided that today (May Day) is the perfect opportunity to express her frustrations with management.

After more than six hours at the table, we finally signed a collective bargaining agreement (CBA) that includes language to extend her bedtime by thirty minutes but also requires her to make sure my sports page and coffee are ready to go each morning, rain or shine.

DAY 865

As I learned in Korea, Alice Bee is very focused on honoring other cultures and their traditions, and our newly signed CBA reflects this — she insisted on including language requiring us to celebrate at home every single holiday she learns about in preschool.

This morning, for example, I noticed that the sports page Alice Bee brought me was written in Spanish. When I asked her about this, she informed me that we were to spend our day celebrating Cinco de Mayo.

Good thing for me, Jen's military preparedness ensures that we always have staples like mayo on hand (I counted at least *ocho* jars in the pantry), so I quickly made Alice Bee's holiday wish come true. For some reason, she didn't appreciate my gesture, and kept insisting that "Mayo" is actually the Spanish word for May and that she wanted us to spend the day celebrating Mexican heritage and culture in a more appropriate manner.

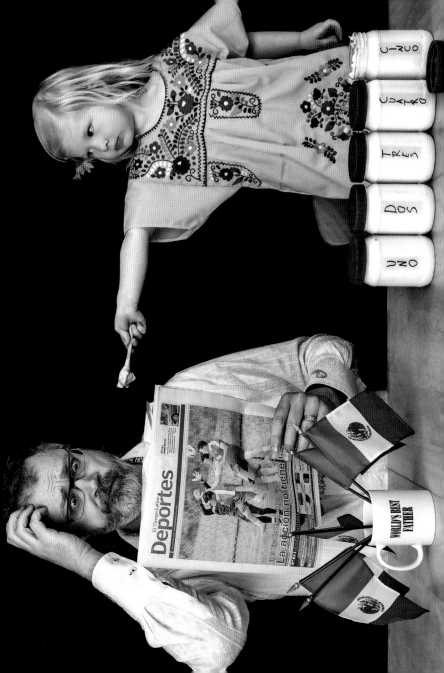

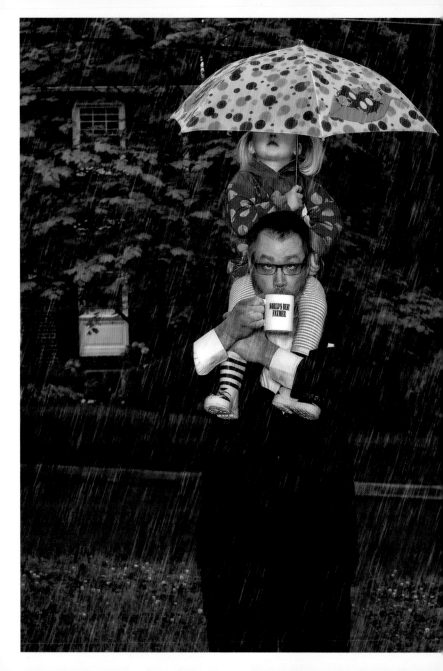

DAY 879

(Transcript from this morning's IM chat with Jen)

WBF42: it's raining and I can't

LTCJEN: make sure Alice Bee
wears her boots and make

WBF42: find my umbrella

LTCJEN: sure she has her umbrella

WBF42: she has an umbrella?

LTCJEN: yes. It's HERS. Not for you

WBF42: where does she keep it?

LTCJEN: in her closet. Do NOT
use it for yourself

WBF42: OK, found it

LTCJEN: give it to her

WBF42: don't worry — umbrella
is in her hands

 **DAY 906**

Tonight before going to bed, Alice Bee told me that she wants the two of us to spend Father's Day together playing superheroes, and that she has a special superhero present she picked out just for me.

I was initially disappointed that she wasn't going to cook breakfast for me like last year, but when I heard about the superhero idea, I started getting really excited. I wonder which superhero she thinks I am. Superman? Iron Man? Maybe even my all-time favorite: Batman! Yeah, I'm sure that's it.

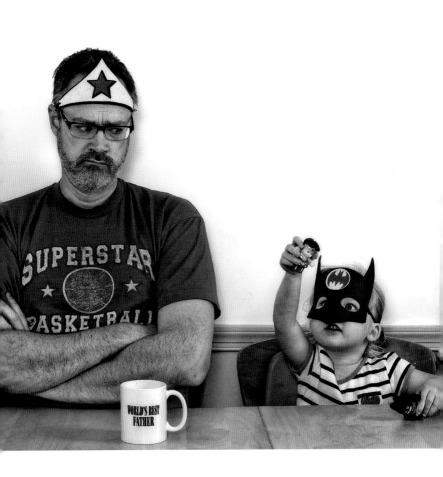

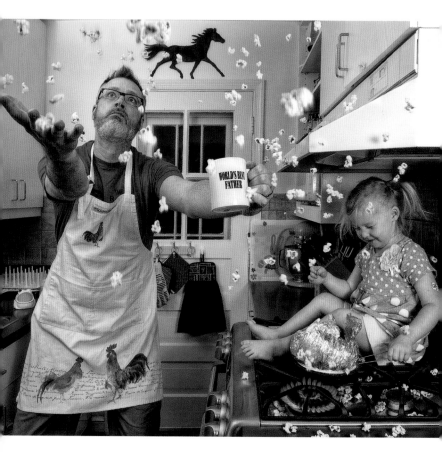

DAY 912

With less than a week until Jen returns from Seoul, Alice Bee and I are having a blast in the final days before the chain of command in our house reverts back to the way it was a year ago.

We've been doing it all — eating spray cheese directly from the can, leaving the seat up when we pee (let's just say that Alice Bee has *skills* when it comes to this), making life-size snowmen out of Cool Whip and eating nothing but fruit snacks and chocolate cake for dinner (with life-size Cool Whip snowmen for dessert).

When I asked Alice Bee what was the one thing she wanted to do before Mommy comes home, she instantly said, "Drive my little car!" Since we were still operating under Jen's strict instructions to not let Alice Bee behind the wheel, we had to settle on her second choice — popping an entire container of popcorn with the lid open. We had so much fun, and because it was stovetop popcorn, we technically didn't even violate Jen's counter rule.

**DAY 918**

Today's the big day! Alice Bee and I are heading to the airport to pick up Jen after a year in Seoul. And to celebrate this big event, I have a surprise in store for Jen and Alice Bee.

I have been diligent about following Jen's rules, which means Alice Bee's ban on driving her toy car has been in effect this entire time. What Jen doesn't know is that I've secretly been teaching Alice Bee to drive using our home videogame console and the GTA IV driving simulator. It was rough going at first, but she quickly picked up on the fundamentals and is now consistently making her way around the fictional digital boroughs of Liberty City with great ease.

I've been planning this reunion in my head for days, and I know exactly how it's going to go. We'll pull up to the airport, I'll hand Jen one of the celebratory beers I have chilling in the backseat, and then sit back and enjoy her surprised reaction as Alice Bee checks the mirrors and begins to drive our freshly reunited family back home.

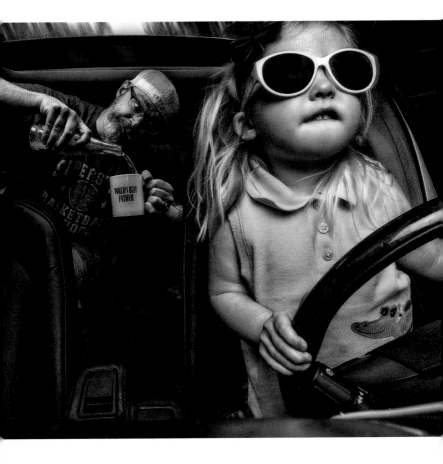

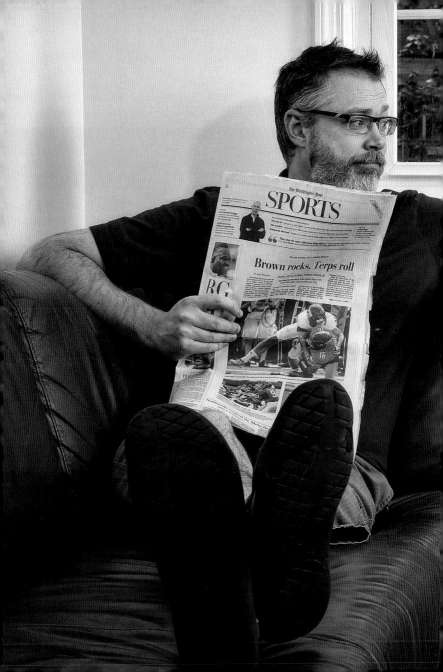

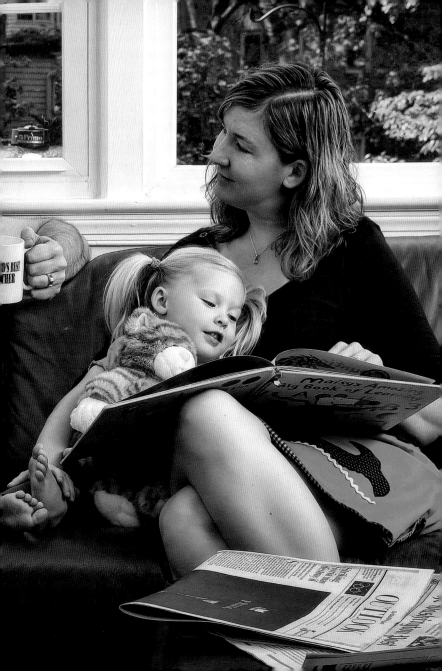

# ACKNOWLEDGMENTS

I want to thank all of our friends (old and new) around the world who have continuously encouraged our family to create and share these images — this book wouldn't have happened without you.

I would also like to thank: my mom for always encouraging me to be silly and creative; my photographic mentor, Dennis Darling, who inspired me so many years ago to think differently about photographing one's children; Steve Ross for being my guide and champion through this entire process; Lauren Marino for taking a chance on us and helping make the final work so much stronger; Seong Jaewoo for serving as our cultural advisor in Seoul, and his mother Lee Myeongsuk for lovingly hand making Alice Bee's beautiful *hanbok;* Sue Zola for the awesome Alice Bee glitter art; Amber Dusick for the "crappy" WBF portrait; and Terri Schipani and the entire Schipani family, whose assistance with and love for Alice Bee helped keep us all sane during Jen's year abroad.

Photo assistants and models: Christie Ciotola, Martha Dodge, Sophia and Willa Falvey, Lisa Gerstner, Aruna Jain, Joe Kekeris, Elijah Kodjak, Matt Morrison, Christian Norton, Karen Nussbaum, Maggie Priebe, Mary and Patrick Quinlan, Monica Samanta, Todd Speight, and Suzanna Vaughan.

Finally, I want to thank Jen for actually being the World's Best Mother as well as my best friend.

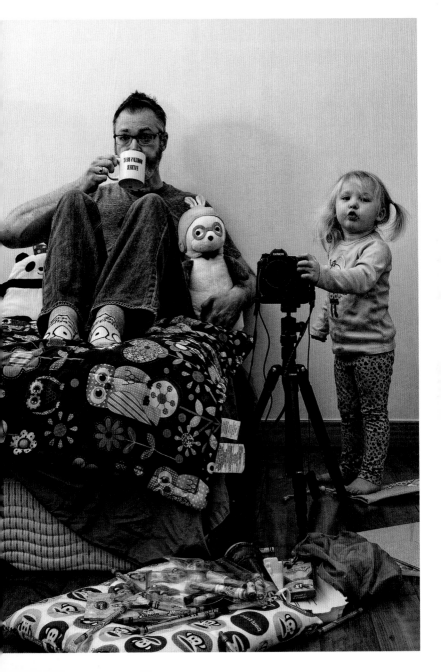

# ABOUT THE AUTHOR

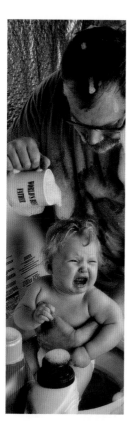

Dave Engledow does not actually hold the title of World's Best Father. He did place a respectable seventh place at the 2012 Montgomery County district meet but has never even advanced to regionals, let alone international competition.

A sixth-generation Texan, Engledow attended the University of Texas at Austin, earning a Bachelor of Journalism in Photojournalism under the mentorship of esteemed documentary photographer Dennis Darling.

Engledow currently lives with his wife, Jen, and their daughter, Alice Bee, in the suburbs of Washington, DC, and spends his days working full-time as the deputy director for Working America. All of the photography, post-processing and writing for *Confessions of the World's Best Father* was done over a two-year period on weekends and at night after Alice Bee had finally gone to bed.